BRUNO MUNARI

DESIGN
AS
ART

Translated by Patrick Creagh

PENGUIN BOOKS

PENGUIN CLASSICS

UK | USA | Canada | Ireland | Australia
India | New Zealand | South Africa

Penguin Books is part of the Penguin Random House group of companies
whose addresses can be found at global.penguinrandomhouse.com.

First published by Editori Laterza 1966
Published in Pelican Books 1971
Reissued in Penguin Classics 2008

031

Copyright © Bruno Munari, 1966
Translation copyright © Patrick Creagh, 1971
All rights reserved

Designed by Germano Facetti
Printed and bound in Great Britain by Clays Ltd, Elcograf S.p.A.

ISBN: 978-0-141-03581-9

www.greenpenguin.co.uk

CONTENTS

Research Design

An artist is a man who digests his own subjective impressions and knows how to find a general objective meaning in them, and how to express them in a convincing form.

MAXIM GORKY

PREFACE TO THE ENGLISH EDITION

In art exhibitions we see less and less of oil paintings on canvas and pieces of sculpture in marble or bronze. Instead we see a growing number of objects made in all sorts of ways of all sorts of materials, things that have no connection with the old-fashioned categories of the visual arts. In the old days of painting these materials and techniques were very much looked down on as inhuman and unworthy of being the vehicles of a Work of Art.

But even in the recent past both painting and sculpture began to lose a few of their bits and pieces. The literary element in a visual work of art was the first to be discarded in favour of pure visuality (Seurat), and it was understood that with the means proper to the visual arts one could say many things that could not be put into words. It was therefore left to literature to tell stories. The disappearance of narrative led to the disappearance of the forms that imitated visible nature, and (with Kandinsky) the first abstract forms entered the scene. These still had shades of colouring, but this naturalistic and representative element was discarded (by Mondrian) in favour of a colour and form that was simply itself and nothing else. From this point it is practically inevitable that we should end up with paintings that are all

of one colour (Klein). This version of the story is rather compressed, but these at any rate are the essential stages in the disappearance of the old categories in art. Eventually the picture is punctured, slashed or burnt alive (Fontana, Burri), and this is the last farewell to techniques that no longer had anything to say to modern man.

The artists of today are busily looking for something that will once again interest the people of today, distracted as they are by a multitude of visual stimuli all clamouring for their attention. If you go to an art exhibition today you may see very simple objects that are so huge that they fill the whole room, some based on statics and others on kinetics. You will find stainless steel used in conjunction with seagull droppings, laminated plastics of every conceivable kind, rigid or inflatable transparent plastic, bits of scrap metal soldered together, and live animals. The artist wants to make the viewer participate at all costs. He is looking for a point of contact, and he wants to sell his works of art in the chain stores just like any other commercial article, stripped of its mystery and at a reasonable price.

But what is at the bottom of this anxiety that drives artists to abandon safe traditional techniques and certain markets, and to sell mass-produced articles in shops and not in galleries?

It is probably the desire to get back into society, to re-establish contact with their neighbours, to create an art for everyone and not just for the chosen few with bags of money. Artists want to recover the public that has long ago deserted the art galleries, and to break the closed circle of Artist — Dealer — Critic — Gallery — Collector.

They want to destroy the myth of the Great Artist, of

the enormously costly Masterpiece, of the one and only unique divine Thing.

They have realized that at the present time subjective values are losing their importance in favour of objective values that can be understood by a greater number of people.

And if the aim is to mass-produce objects for sale to a wide public at low price, then it becomes a problem of method and design. The artist has to regain the modesty he had when art was just a trade, and instead of despising the very public he is trying to interest he must discover its needs and make contact with it again. This is the reason why the traditional artist is being transformed into the designer, and as I myself have undergone this transformation in the course of my working career I can say that this book of mine is also a kind of diary in which I try to see the why and wherefore of this metamorphosis.

1970 BRUNO MUNARI

PREFACE

The Useless Machines

Lots of people know of me as 'You know, the man who made the useless machines', and even today I still occasionally get asked for one of these objects, which I designed and made in about 1933. That was the time when the movement called the 'novecento italiano' ruled the roost, with its High Court of super-serious masters, and all the art magazines spoke of nothing else but their granitic artistic productions; and everyone laughed at me and my useless machines. They laughed all the harder because my machines were made of cardboard painted in plain colours, and sometimes a glass bubble, while the whole thing was held together with the frailest of wooden rods and bits of thread. They had to be light so as to turn with the slightest movement of the air, and the thread was just the thing to prevent them getting twisted up.

But all my friends rocked with laughter, even those I most admired for the energy they put into their own work. Nearly all of them had one of my useless machines at home, but they kept them in the children's rooms because they were absurd and practically worthless, while their sitting-rooms were adorned with the sculpture of Marino Marini and paintings by Carrà and Sironi. Certainly, in comparison

with a painting by Sironi, scored deeply by the lion's claw of feeling, I with my thread and cardboard could hardly expect to be taken seriously.

Then these friends of mine discovered Alexander Calder, who was making mobiles; but his things were made of iron and painted black or some stunning colour. Calder triumphed in our circle, and I came to be thought of as his imitator.

What is the difference between my useless machines and Calder's mobiles? I think it is best to make this clear, for apart from the different materials the methods of construction are also quite distinct. They have only two things in common: both are suspended and both gyrate. But there are thousands of suspended objects and always have been, and I might point out that my friend Calder himself had a precursor in Man Ray, who in 1920 made an object on exactly the same principles later used by Calder.

There is a harmonic relationship between all the parts

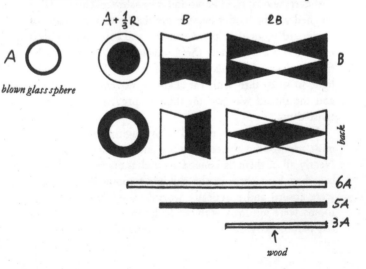

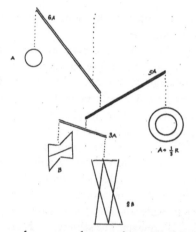

which go to make up a useless machine. Let us suppose that we start with a glass ball, marked A in the illustration. From this we obtain the disc $A+\frac{1}{3}R$ by simply adding one third to the radius of the ball and marking the dimensions of the ball inside the cardboard disc. The diameter of this disc determines the other two geometric forms B and 2B (the one being just double the other). The backs of these forms are painted as the negatives of the fronts. The wooden rods to which the shapes are attached are also measured in relation to the diameter of the ball: 3A, 5A and 6A. The whole thing is then balanced up and hung on a piece of thread.

Mobiles are by nature different. The inspiration for them seems to be drawn from the vegetable kingdom. One might say that Calder was the first sculptor of trees. There are plenty of sculptors of figures and animals, but trees in the sense of living things that oscillate, with branches of progressive dimensions and with leaves on the branches, these had never been done. Take a branch with its leaves still on and you are looking at a mobile by Calder. They

have the same principle, the same movement, the same dynamic behaviour.

But the pieces of a useless machine all turn upon themselves and in respect to each other without touching. Their basis is geometrical, while the two differently coloured faces give a variety of colour-effects as the forms turn. People have often wondered how the idea originated, and here is the answer. In 1933 they were painting the first abstract pictures in Italy, and these were nothing more than coloured geometric shapes or spaces with no reference at all to visible nature. Very often these abstract paintings were still lives of geometric forms done in realistic style. They used to say that Morandi made abstract pictures by using bottles and vases as formal pretexts. The subject of a Morandi canvas is in fact not the bottles, but painting enclosed within those spaces. Bottles or triangles were therefore the same thing, and the painting emerged from the relationships of its forms and colours.

Now I myself thought that instead of painting triangles and other geometrical forms within the atmosphere of an oblong picture (for this — look at Kandinsky — was still essentially realistic) it would perhaps be interesting to free these forms from the static nature of a picture and to hang them up in the air, attached to each other in such a way as to live with us in our own surroundings, sensitive to the atmosphere of real life, to the air we breathe. And so I did. I cut out the shapes, gave them harmonic relationships to one another, calculated the distances between them, and painted their backs (the part one never sees in a picture) in a different way so that as they turned they would form a variety of combinations. I made them very light and used thread so as to keep them moving as much as possible.

Whether or not Calder started from the same idea, the fact is that we were together in affirming that figurative art had passed from two or at the most three dimensions to acquire a fourth: that of time.

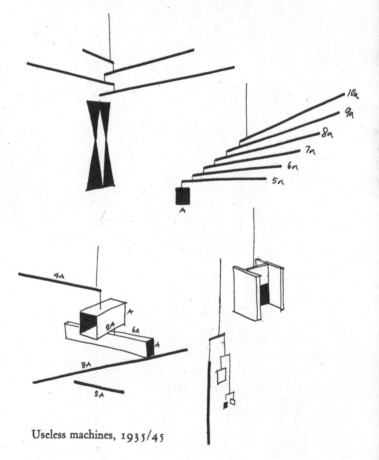

Useless machines, 1935/45

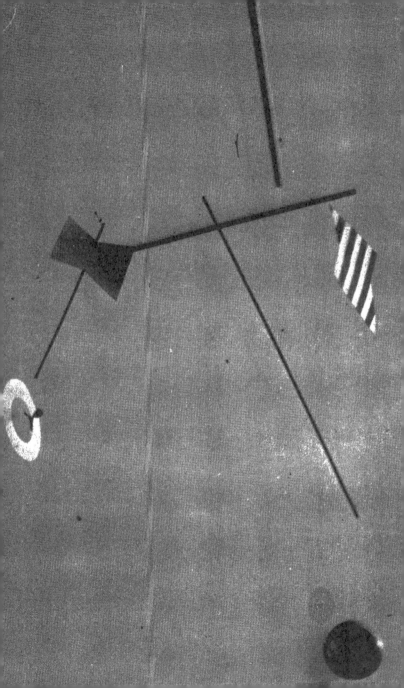

Other types of 'useless machine' designed in the period 1935–54 and made of balsawood, cardboard and thread. Some were made of flexible wire and wooden rods. The components were always tied together with thread. The wire gave a special springiness to the wooden rods.

A useless machine which
was mass-produced
in aluminium (1952).

The name 'useless machine' lends itself to many interpretations. I intended these objects to be thought of as machines because they were made of a number of movable parts fixed together. Indeed, the famous lever, which is only a bar of wood or iron or other material, is nevertheless a machine, even if a rudimentary one. They are useless because unlike other machines they do not produce goods for material consumption, they do not eliminate labour, nor do they increase capital. Some people declared that on the contrary they were extremely useful because they produced goods of a spiritual kind (images, aesthetic sense, the cultivation of taste, kinetic information, etc.). Others confused these useless machines, which belong to the world of aesthetics, with the comic machines I invented during my student days with the sole purpose of making my friends laugh. These comic machines were later published by Einaudi in a book (long since out of print) called *Le Macchine di Munari*. They were projects for strange constructions for wagging the tails of lazy dogs, for predicting the dawn, for making sobs sound musical, and many other facetious things of that kind. They were inspired by the famous American designer Rube Goldberg, but British readers will more easily recall Heath Robinson, who was working in a similar field.

'Machines would not exist without us, but our existence would no longer be possible without them.' (*Pierre Ducassé*)

DESIGN AS ART

Today it has become necessary to demolish the myth of the 'star' artist who only produces masterpieces for a small group of ultra-intelligent people. It must be understood that as long as art stands aside from the problems of life it will only interest a very few people. Culture today is becoming a mass affair, and the artist must step down from his pedestal and be prepared to make a sign for a butcher's shop (if he knows how to do it). The artist must cast off the last rags of romanticism and become active as a man among men, well up in present-day techniques, materials and working methods. Without losing his innate aesthetic sense he must be able to respond with humility and competence to the demands his neighbours may make of him.

The designer of today re-establishes the long-lost contact between art and the public, between living people and art as a living thing. Instead of pictures for the drawing-room, electric gadgets for the kitchen. There should be no such thing as art divorced from life, with beautiful things to look at and hideous things to use. If what we use every day is made with art, and not thrown together by chance or caprice, then we shall have nothing to hide.

Anyone working in the field of design has a hard task

ahead of him: to clear his neighbour's mind of all precon-
ceived notions of art and artists, notions picked up at schools
where they condition you to think one way for the whole
of your life, without stopping to think that life changes –
and today more rapidly than ever. It is therefore up to us
designers to make known our working methods in clear and
simple terms, the methods we think are the truest, the most
up-to-date, the most likely to resolve our common aesthetic
problems. Anyone who uses a properly designed object feels
the presence of an artist who has worked for *him*, bettering
his living conditions and encouraging him to develop his
taste and sense of beauty.

When we give a place of honour in the drawing-room to
an ancient Etruscan vase which we consider beautiful, well
proportioned and made with precision and economy, we
must also remember that the vase once had an extremely
common use. Most probably it was used for cooking-oil. It
was made by a designer of those times, when art and life
went hand in hand and there was no such thing as a work of
art to look at and just any old thing to use.

I have therefore very gladly accepted the proposal that
I should bring together in a volume the articles I originally
published in the Milanese paper *Il Giorno*. To these I have
added other texts, as well as a lot of illustrations which it
was not possible to publish in the limited space of a daily
paper. I have also made a few essential changes for the
English edition.

I hope that other designers will make similar efforts
to spread knowledge of our work, for our methods are daily
asserting themselves as the fittest way of gaining the con-
fidence of men at large, and of giving a meaning to our
present way of life.

Design came into being in 1919, when Walter Gropius founded the Bauhaus at Weimar. Part of the prospectus of this school reads:

'We know that only the technical means of artistic achievement can be taught, not art itself. The function of art has in the past been given a formal importance which has severed it from our daily life; but art is always present when a people lives sincerely and healthily.

'Our job is therefore to invent a new system of education that may lead – by way of a new kind of specialized teaching of science and technology – to a complete knowledge of human needs and a universal awareness of them.

'Thus our task is to make a new kind of artist, a creator capable of understanding every kind of need: not because he is a prodigy, but because he knows how to approach human needs according to a precise method. We wish to make him conscious of his creative power, not scared of new facts, and independent of formulas in his own work.'

From that time on we have watched an ever more rapid succession of new styles in the world of art: abstract art, Dada, Cubism, Surrealism, Neo-Abstract art, Neo-Dada, pop and op. Each one gobbles up its predecessor and we start right back at the beginning again.

What Gropius wrote is still valid. This first school of design did tend to make a new kind of artist, an artist useful to society because he helps society to recover its balance, and not to lurch between a false world to live one's material life in and an ideal world to take moral refuge in.

When the objects we use every day and the surroundings we live in have become in themselves a work of art, then we shall be able to say that we have achieved a balanced life.

DESIGNERS AND STYLISTS

What is a Designer?

He is a planner with an aesthetic sense. Certain industrial products depend in large measure on him for their success. Nearly always the shape of a thing, be it a typewriter, a pair of binoculars, an armchair, a ventilator, a saucepan or a refrigerator, will have an important effect on sales: the better designed it is, the more it will sell.

The term 'designer' was first used in this sense in America. It does not refer to an industrial designer, who designs machines or mechanical parts, workshops or other specialized buildings. He is in fact a design engineer, and if he has a motor-scooter on the drawing-board he does not give a great deal of importance to the aesthetic side of things, or at the most he applies a personal idea of what a motor-scooter ought to look like. I once asked an engineer who had designed a motor-scooter why he had chosen a particular colour, and he said: because it was the cheapest. The industrial designer therefore thinks of the aesthetic side of the job as simply a matter of providing a finish, and although this may be most scrupulously done he avoids aesthetic problems that are bound up with contemporary culture because such things are not considered useful. An engineer must never be caught writing poetry. The designer

works differently. He gives the right weight to each part of the project in hand, and he knows that the ultimate form of the object is psychologically vital when the potential buyer is making up his mind. He therefore tries to give it a form as appropriate as possible to its function, a form that one might say arises spontaneously from the function, from the mechanical part (when there is one), from the most appropriate material, from the most up-to-date production techniques, from a calculation of costs, and from other psychological and aesthetic factors.

In the early days of rationalism it used to be said that an object was beautiful in so far as it was functional, and only the most practical functions were taken into account. Various kinds of tool were used as evidence for this argument, such as surgical instruments. Today we do not think in terms of beauty but of formal coherence, and even the 'decorative' function of the object is thought of as a psychological element. For beauty in the abstract may be defined as what is called style, with the consequent need to force everything into a given style because it is new. Thus in the recent past we have had the aerodynamic style, which has been applied not only to aeroplanes and cars but to electric irons, perambulators and armchairs. On one occasion I even saw an aerodynamic hearse, which is about as far as the aerodynamic style can go (speeding the departing guest?).

We have therefore discarded beauty in the abstract sense, as something stuck on to the technical part of a thing, like a stylish car body or a decoration tastefully chosen from the work of some great artist. Instead we have formal coherence, rather as we see it in nature. A leaf has the form it has because it belongs to a certain tree and fulfils a certain

function; its structure is determined by the veins which carry the sap, and the skeleton that supports it might have been worked out by mathematics. Even so, there are many kinds of leaf, and the leaves of any single tree differ slightly among themselves. But if we saw a fig-leaf on a weeping-willow we would have the feeling that all was not well. It would lack coherence. A leaf is beautiful not because it is stylish but because it is natural, created in its exact form by its exact function. A designer tries to make an object as naturally as a tree puts forth a leaf. He does not smother his object with his own personal taste but tries to be objective. He helps the object, if I may so put it, to make itself by its own proper means, so that a ventilator comes to have just the shape of a ventilator, a *fiasco* for wine has the shape that blown glass gives it, as a cat is inevitably covered with cat-fur. Each object takes on its own form. But of course this will not be fixed and final because techniques change, new materials are discovered, and with every innovation the problem arises again and the form of the object may change.

At one time people thought in terms of fine art and commercial art, pure art and applied art. So we used to have sewing-machines built by engineers and then decorated by an artist in gold and mother-of-pearl. Now we no longer have this distinction between fine and not-fine, pure and applied. The definition of art that has caused so much confusion in recent times, and allowed so many fast ones to be pulled, is now losing its prestige. Art is once more becoming a trade, as it was in ancient times when the artist was summoned by society to make certain works of visual communication (called frescoes) to inform the public of a certain religious event. To-day the designer (in this case the graphic designer) is called

upon to make a communication (called a poster) to inform the public of some new development in a certain field. And why is it the designer who is called upon? Why is the artist not torn from his easel? Because the designer knows about printing, about the techniques used, and he uses forms and colours according to their psychological functions. He does not just make an artistic sketch and leave it up to the printer to reproduce it as best he may. He thinks from the start in terms of printing techniques, and it is with these that he makes his poster.

The designer is therefore the artist of today, not because he is a genius but because he works in such a way as to re-establish contact between art and the public, because he has the humility and ability to respond to whatever demand is made of him by the society in which he lives, because he knows his job, and the ways and means of solving each problem of design. And finally because he responds to the human needs of his time, and helps people to solve certain problems without stylistic preconceptions or false notions of artistic dignity derived from the schism of the arts.

'The form follows the function.' (*Jean-Baptiste Lamarck*)

The designer works in a vast sector of human activity: there is visual design, industrial design, graphic design and research design.

Visual design is concerned with images whose function is to communicate and inform visually: signs, symbols, the meaning of forms and colours and the relations between these.

Industrial design is concerned with functional objects, designed according to economic facts and the study of techniques and materials.

Graphic design works in the world of the Press, of books, of printed advertisements, and everywhere the printed word appears, whether on a sheet of paper or a bottle.

Research design is concerned with experiments of both plastic and visual structures in two or more dimensions. It tries out the possibilities of combining two or more dimensions, attempts to clarify images and methods in the technological field, and carries out research into images on film.

Pure and Applied

Once upon a time there was pure art and applied art (I prefer to use these terms, rather than 'fine' and 'commercial', because 'commercial art' does not really cover enough ground). At all events, forms were born in secret in ivory towers and fathered by divine inspiration, and Artists showed them only to initiates and only in the shape of paintings and pieces of sculpture: for these were the only channels of communication open to the old forms of art.

Around the person of the Artistic Genius there circulated other and lesser geniuses who absorbed the Pure Forms and the Style of the Master and attempted to give these some currency by applying them to objects of everyday use. This led to the making of objects in this style or that style, and even today the question of Style has not been altogether disposed of.

The distinction between pure art, applied art and industrial design is still made in France, a country that at one time was the cradle of living art. What we call design, the French call 'esthétique industrielle', and by this phrase they mean the application to industry of styles invented in the realm of the pure arts.

It therefore comes about that in France they make lamps

inspired by abstract forms without bearing in mind that a lamp must give light. They design a Surrealist television set, a Dada table, a piece of 'informal' furniture, forgetting that all objects have their exact uses and well-defined functions, and that they are no longer made by craftsmen modelling a stylish shape in copper according to their whim of the moment but by automatic machines turning out thousands of the things at a time.

What then is this thing called Design if it is neither style nor applied art? It is planning: the planning as objectively as possible of everything that goes to make up the surroundings and atmosphere in which men live today. This atmosphere is created by all the objects produced by industry, from glasses to houses and even cities. It is planning done without preconceived notions of style, attempting only to give each thing its logical structure and proper material, and in consequence its logical form.

So all this talk about sober harmony, beauty and proportions, about the balance between masses and spaces (typical sculpture-talk), about aesthetic perfection (classicism?), about the charm of the materials used and the equilibrium of the forms, all this talk our French friends go in for, is just a lot of old-fashioned claptrap. An object should now be judged by whether it has a form consistent with its use, whether the material fits the construction and the production costs, whether the individual parts are logically fitted together. It is therefore a question of coherence.

Beauty as conceived of in the fine arts, a sense of balance comparable with that of the masterpieces of the past, harmony and all the rest of it, simply make no more sense in design. If the form of an object turns out to be 'beautiful' it will be thanks to the logic of its construction and to the preci-

sion of the solutions found for its various components. It is 'beautiful' because it is just right. An exact project produces a beautiful object, beautiful not because it is like a piece of sculpture, even modern sculpture, but because it is only like itself.

If you want to know something else about beauty, what precisely it is, look at a history of art. You will see that every age has had its ideal Venus (or Apollo), and that all these Venuses or Apollos put together and compared out of the context of their periods are nothing less than a family of monsters.

A thing is not beautiful because it is beautiful, as the he-frog said to the she-frog, it is beautiful because one likes it.

'The basic teaching error of the academy was that of directing its attention towards genius rather than the average.' (*Bauhaus*)

A Living Language

'Good language alone will not save mankind. But seeing the things behind the names will help us to understand the structure of the world we live in. Good language will help us to communicate with one another about the realities of our environment, where we now speak darkly, in alien tongues.'
(*Stuart Chase*, The Tyranny of Words)

'. . . And after whan ye han examined youre conseil, as I han said beforne, and knowen wel that ye moun performe youre emprise, conferme it than sadly til it be at an ende.' Can one now address the public in the language of the fourteenth century? It is most unlikely that the public would understand.

Just as there are dead languages, it is natural that there should be modes of expression and communication that have gone out of use. It is a well-known fact that to get a message across we can use not only words, but in many cases also images, forms and colours, symbols, signs and signals. Just as there are words which belong to other ages, so there are colours, forms, signs and so on which in our time have come to mean nothing, or would convey a wrong meaning.

What does a blacksmith's sign mean to the children of today? To children in 1900 it meant a lot: it meant excitement. When they saw it they ran to watch the blacksmith hammering the glowing iron on his anvil, heating it every now and then in a furnace that threw off sparks like a firework display, nailing the finished shoe to the horse's hoof. Imagine the pungent stench of the hot iron, and the huge impassive horse tethered to an iron ring set in the blackened wall of that smoky cavern. . . .

Maybe a city child of today doesn't even know what a horseshoe is, and for this reason an object that was a symbol and a sign that evoked many images and meanings is now reduced to the status of a lucky charm.

We can point out similar changes in the colours used for visual communication. Looking into the past we find certain periods dominated by certain colours and forms: periods in which all the colours are earthy and the forms hard, some in which the whole range of colours is put to use, others in which everything is done with three or four colours. And so on down to our own times, when thanks to chemistry, plastic materials and other inventions, the kingdom of colour is governed by total chaos.

Certainly if we now used the colours of the 'art nouveau' period for roadsigns, these would fade magnificently into their surroundings. At that time they used some really refined combinations of colour. A faint idea of them can still be had from Roberts's talcum powder boxes and the labels on Strega bottles. They used to put pink and yellow side by side, or brown and blue, coffee and chocolate, pea-green and violet. Then they would make unexpected leaps from one shade to another, putting red with pale blue (instead of dark) and so on. Can we imagine a 'No Overtaking' sign with a coffee and chocolate car on a violet background? Well, yes. We can imagine it for fun, but we cannot use it for a roadsign in real life.

At some times in the past a certain series of colours, let us say all of dark tone, were indiscriminately adapted to all branches of human activity. The colours used for furnishings did not differ much from those for clothes or carriages. But today different colours have different uses. For roadsigns we use only red, blue and yellow (apart from the green light at

traffic lights), and each colour has its well-defined meaning. In advertising we use bright brash colours or very refined ones according to our purpose. In printing we use the dull four-colour system which reduces all colours to a norm, while women's fashions make use of all the colours in rotation.

A double-bend sign in the style of Louis XIV. There have always been dangerous double bends, even in the time of Louis XIV, but then there were no roadsigns. They had heraldic arms instead. As the speed and volume of traffic increases, decoration is proportionally reduced, until it reaches the bare essentials of our present-day signals. Visual language changes according to the needs of the day.

In the past, images were nearly all painted, drawn or carved, and they reproduced visible and recognizable reality. Now we can even see the invisible. We have a host of machines exploring for us what we cannot see with the naked eye. We have X-ray photos, the world of the microscope, and the abstract inventions of artists. We have machines that enable us to see music and sounds in the form of luminous waves, machines that show us photo-elasticity in colour by means of polarized light, machines that slow up pictures of motion until we get as it were a blow-up of each instant. Then there are the lights which already form an accepted part of the nightscape, fluorescent lights, neon, sodium vapour lights, black light. And we have forms that are beautiful and exact because they are true forms: the forms of aeroplanes and missiles are dictated by the demands of speed, and were inconceivable in the past. These are forms we see every day, the colours and lights of our own time. To accept, to know and to use them is to express oneself in the language of today which was made for the man of today.

A Rose is a Rose is a

And then you go up to it and see, for the sake of argument, that it is an artificial rose. Then you become aware of the material it is made of, cloth or plastic or paper. But at first glance you were certain of one thing only, that it was a rose. This apparently insignificant fact is the subject of careful study today, for it is vital to the problems of visual communication.

All over the world psychologists, designers and research workers in other fields are trying to understand and establish objective rules that will enable us to use these means of visual communication with increasing precision.

The growing use of symbols such as roadsigns and trademarks on a worldwide scale demands absolute clarity of expression. It is no longer possible to confine oneself to local tastes. If a visual message is going to get across to people of different languages and backgrounds it is essential that the message does not lend itself to wrong interpretations. Another point is the speed at which signs can be read, though now we are pretty well trained to take them in in the blinking of an eye. Reading them is a matter of conditioning, and we do it without thinking, as when we put our foot on the brake when we see a red light. We are surrounded by countless

visual stimuli, posters that flash past the car windows, lighted signs, blinking lights, images that crowd in upon us on every side, and all intent on telling us something. We have already made a catalogue of stimuli in our own minds, and the process goes on without pause. Almost without realizing it we arrange these images in order, rejecting those that do not interest us. We already know that roadsigns occur at a certain height above the ground and have exactly those shapes and colours and no others.

Putting things in pigeon-holes like this helps us to make snap readings of signs, and today it is important to have quick reflexes, so as not to waste time, or worse.

All over the world this kind of lettering conveys an immediate message: 'strip cartoon'. Even before we read what it says. It goes without saying that an essay on Giotto as an architect ought not to have a title in such lettering. I know this is an exaggeration, and that no one would in fact think of using lettering like this for such a subject, but exaggeration often throws light upon the negative aspects of a problem (in this case a problem of graphic design). Between these letters and the right kind for the job there is a vast range of letters to choose from, both printed and drawn, and countless ways of arranging the title. Often a firm unwilling to call in a graphic designer will use lettering suited to cheese to present a book of famous artists, and we may see an advertisement for the Bible which looks at first sight as if it were trying to sell us beer.

So we all have inside us (naturally with some variation
from person to person) groups of images, forms and colours
which have exact meanings. There are masculine forms and
colours and feminine forms and colours, warm colours and
cold colours, images of violence and images of gentleness,
images connected with culture and the arts and others that
are just plain vulgar. It goes without saying that if I have to
publicize a cultural campaign on behalf of works of art I must
not use vulgar colours, lettering associated with ads for can-
ned foods, or a brash method of composition. On the con-
trary, I must immediately convey the idea that here we are
dealing with something lofty and not to be compared in any
way with commonplace things. A lot of people think that
the public does not understand such matters, but it is not a
question of understanding. There is a whole mechanism
already at work on its own, quite independent of logic or
reason. It is true that a badly designed poster will have some
effect if the walls are smothered with it, but a good poster
would achieve the same results less wastefully by giving more
pleasure.

Unhappily there is a lot of confusion and waste in these
messages that surround us. They often weary us with their
petulance, their insistence on cramming things we don't want
down our throats, and (what is worse) doing it clumsily.

There is one American catalogue that gives a choice of one
thousand two hundred colours, and that's not all of them. In
the face of this one simply cannot go on using the same red as
a background for quite different products, for car tyres, per-
fumes and foodstuffs, as if one had no other resources. The
eye of the beholder is hopelessly muddled, and his first im-
pression, which will determine whether he is interested or
not, is a vague and indefinite one.

The same can be said of form. There are things on sale that demand a tremendous effort to guess at their proper use. With the confusion of form that persists today a brush can look like a cat, a lamp like a weighing machine, a home like an office and an office like a drawing-room, a bank like an electrician's workshop and a church like a stand at the Earls Court Exhibition.

The Stylists

One of the commonest aspects of design, and one of the most facile, is styling. It is within the scope of all those who have artistic stirrings, who sign their work with a generous flutter of calligraphy as if setting their mark on a romantic master-piece, and whose lips are constantly laden with the words Poetry and Art.

Styling is a kind of industrial designing, and of all branches of design the most ephemeral and superficial. It does no more than give a veneer of fashion, a contemporary 'look', to any object whatever. The stylist works for the quick turnover, and takes his ideas from the fads of the day. The 'aero-dynamic' period was the Golden Age for stylists.

What most interests a stylist is line, sculptural form, a bizarre idea. A little science fiction does no harm and a sense of elegance is basic.

The project (let's say a car body) is first sketched out with coloured pencils. The stylist strikes while the iron is hot, perhaps making a thumbnail sketch on the back of a cigarette packet. The great thing is to get it down before inspiration cools. Then it is worked out in more detail and on a bigger scale, using artists' charcoals. This second sketch is always done with a great flaunting of perspective and with dazzling

highlights: the car is shown by night on a wet road so as to make the utmost of these highlights. One sees something similar in those drawings of seaside and suburban villas in which the clouds behind and the tree before the house make ever such a nice picture.

They then make a plaster model, as sculptors do, and the joints and relative volumes are studied. While the stylist is at work he feels all the great artists of the past breathing over his shoulder, and he wants his design to be worthy of standing beside the Venus de Milo or a Palladian villa without looking foolish: indeed, these styled cars often are photographed standing confidently in front of some masterpiece of the past.

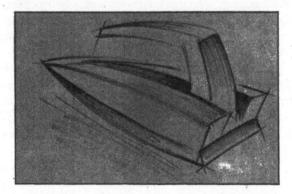

Is this a flatiron or a speedboat? Someone turned up this sketch by the famous American stylist Bernard Tettamanzi (it was he who created that fabulous car for Peter Zunzer), but there is no scale marked on the drawing. There is no way of knowing the life-size of the object sketched out in such a masterly fashion with the point of a Flomaster. It could be an iron, it could be a speedboat. Opinions vary. Maybe it's simply a handle with a handle on it. In any case, it's got *style*.

In the United States stylists are responsible for giving a new look to a car or other object that has flooded the market and is no longer selling. Leaving the vital parts inside the car alone, they dress it up in a new suit, launch a new fashion and spread the word that the old style is Out. So everyone who sets great store by his dignity rushes out to buy the new model for fear of being thought old hat.

What does fashion actually do? It sells you a suit made of a material that could last five years, and as soon as you have bought it tells you that you can't wear it any longer because a newer one has already been created. The same principle can be used to sell anything. The motto of styling is 'It's Out'. As soon as one thing is sold they must invent another to supersede it.

The stylist therefore works by contrasts. If curves were In yesterday, square corners are In today. Out with delicate colours, in with bright ones. It is well known that women's fashions work the same way. A fashionable colour reaches saturation point and everyone longs only to see its opposite, so that an excess of violet produces a desire for yellow. After a season of violet, then, one can fairly reliably predict a season of yellow.

Obviously this way of carrying on is quite different from the true designer's working method, for the designer takes no notice of the styles and forms of 'pure' art for the simple reason that a statue and a car body are two distinct problems, and the colours of a painting have nothing in common with the colours of mass-produced plastic objects.

A designer with a personal style, arrived at *a priori*, is a contradiction in terms. There is no such thing as a personal style in a designer's work. While a job is in hand, be it a lamp, a radio set, an electrical gadget or an experimental object, his sole

concern is to arrive at the solution suggested by the thing itself and its destined use. Therefore different things will have different forms, and these will be determined by their different uses and the different materials and techniques employed.

Mystery Art

The children come out of school happy and laughing, strolling contentedly along or running at full tilt, shouting good-byes to one another and snapping their books shut in each other's faces, pushing and shoving and thumping backs. They go home on foot or by bike or in the vast black limousine chauffeured by a peaked cap and a pair of white gloves.

But meanwhile an idea has been implanted in their minds that will be difficult to change for the rest of their lives. Among other things, they have learnt that art is confined to painting, sculpture, poetry and architecture.... That painting is done with oil on canvas, that sculpture is three-dimensional and made of bronze or marble, that poetry is language made to rhyme, that architecture.... That the most beautiful art is that of the distant past, that modern art stopped being good after the Impressionists, that visual art imitates nature, and that in painting and sculpture there must be a meaning (that is, a literary content) or it is not art.

And in fact you only have to go to a proper museum to see what visual art really is, and how paintings and pieces of sculpture have to be made, with due allowance for different styles and periods of course, and of course with the exception of our own period.

Then perhaps these children happen to see an exhibition of modern sculpture, and come face to face with a perfectly flat statue, a statue with no profile and no third dimension, or a painting with coloured things stuck on to its surface, in which the *bas relief* effect is of the greatest importance. A painting in three dimensions. And yet the three-dimensional picture is behind glass in a gilt frame and the two-dimensional statue is on a pedestal. How are they to come to terms with these contradictions?

But this is nothing compared with what they might meet with later on. For example, a huge painting expressing social protest, with poor peasants being kicked to death by capitalists (a very expensive painting, such as you will only find in the drawing-rooms of capitalist country houses on the shores of Lake Como). But this picture is done in Impressionist-Cubist style, using strong colours and a very simple pictorial design, because although it is a unique piece and very expensive it has to be readily understood by everyone. Or take another kind of protest picture, made of rubbish, rags and old iron (there are pieces of sculpture like this too) all thrown together into a frame, though naturally by the hand of an artist. This is a work of art, a *unique* work of art, and very nice it will look — such an artistic contrast — among the cut glass and shining silverware of a prosperous middle-class home. It will bear witness to how indulgent we solid men are towards the wicked artist.

How is it that our times are producing such works of art? A realistic monochrome picture of a lavatory seat. A transparent plastic box full of second-hand dentures. A tinned blackbird signed by the artist. Ten one pound tins of the same. A tailor's dummy painted white, a canvas bundle tied with 100,000 different pieces of string, a machine that does your

doodles for you. A picture made by pouring on paint at random. A postcard of Portsmouth twelve feet by six. A toothpaste tube twelve yards long. A blown-up detail of a strip-cartoon.

Is this not perhaps the mirror of our society, where the incompetent landlubbers are at the helm, where deceit is the rule, where hypocrisy is mistaken for respecting the opinions of others, where human relationships are falsified, where corruption is the norm, where scandals are hushed up, where a thousand laws are made and none obeyed?

But what about the art critics whose job it is to explain these things and make them clear? What have they got to say about it? They say that here we have a lyric poem in pure frontal visuality that avoids three-dimensional language in order to reinstate man in the field of semantic-entropic discourse so as to achieve a new dimension that is quite the reverse of Kitsch and exists on the plane of objectivized and reversible Time as Play. . . .

That is why young people are all in love with the Beatles and live in houses with good solid nineteenth-century pictures, like the pictures they are taught about at school.

Why have we become like gods as technologists and like devils as moral beings, supermen in science and idiots in aesthetics — idiots above all in the Greek sense of absolutely isolated individuals, incapable of communicating among themselves or understanding one another? (*Lewis Mumford*)

VISUAL DESIGN

Character Building

In the world of publicity there are Rules for visual communication. These Rules are arrived at by Research and Questionnaires which are then boiled down into Statistics, and these tell us that a woman's face must be of such and such a type and no other, that it must be photographed in a particular way, that it must be wearing a certain kind of expression and looking at the public, like the Mona Lisa.

It has to be this way because the Public wishes it so. And as this Rule is a General Rule, all women are made to look the same in the advertising world, with the same face photographed in the same way. Likewise, all the babies whose innocence is exploited to push dried milk and biscuits and talcum powder are perfectly identical.

How is one to distinguish at a glance between a motor-tyre poster (with female figure) and one for a fizzy drink (with ditto)? There once was a company that always put lots of women in its advertisements, and whenever one saw a poster of theirs one knew it was that company advertising their. . . . I can't quite remember what they used to sell. Now we have countless cameras clicking away and taking exactly the same sort of photo for every product.

It therefore seems plain to me that we must add a footnote

to the General Rules for making a good poster. We must introduce the notion of character, so that without losing any of its impact a poster for motor-tyres can easily be distinguished from posters for beer or Bibles. And vice versa.

It is not true to say that all posters today are the same. There are differences, but except in rare cases these differences are based purely on chance. They depend on the taste of the artist, who just happened to see things that way. He has a style of his own, as they used to say in the old days. But the style should rather be that of the thing being advertised, so as to make it instantly recognizable.

An artist's style is a leftover of romanticism, and is generally damaging to the goods he is advertising, unless (as has sometimes happened) a firm simply takes over an artist, style and all, and makes him its personal property.

The problem is therefore how to give individual character to images, whether we are dealing with an isolated poster or an entire campaign. How can we do this? We have, of course, famous examples in the realm of the fine arts, but it is just not good enough to pick a style and apply it at random. There must be coherence between the product and the forms and colours used.

There are products which already have strongly distinct characters of their own, and in themselves contain the images of the world in which they will be used. And each 'world', each limited group of consumers, has its images, ranging from those of comics for children to those of the classics for the average adult. There are thousands of ways of photographing or drawing the human face. Look at a book of contemporary photographs and you will see for yourself. A poster recommending concentrated soups is designed to reach a different public from one announcing the call-up of

conscripts into the armed forces. But posters and advertising in general are nearly always totally divorced from culture. And by culture I do not mean what is taught in schools and can readily be found in books. I mean living culture, knowledge of what is happening in the arts today, the efforts living artists are making to find expressive forms. They are not classical artists or romantic artists, but seekers after images who use all the scientific and technical means available. Only a knowledge of their experiments can provide the distinctive quality posters need if they are to be something more than general information aimed at everyone and no one. Visual characterization makes for directness and immediacy. People haven't got time to stop in the street, size a poster up, see what it refers to and then decide whether or not it interests them. Communication must be instant and it must be exact.

Variations on the Theme of the Human Face

In how many ways and with what techniques can one produce variations on the human face seen from the front? The graphic designer works without set limits and without rejecting any possible technique. His experiments in the visual lead him to try out all possible combinations and methods in order to arrive at the precise image he needs for the job in hand, and no other.

Looking at the techniques of the past we notice that a human face made in mosaic has a different structure from one painted on a wall, drawn in chiaroscuro, carved in stone, and so on.

The features — eyes, nose and mouth — are 'structured' differently. In the same way if one is thinking of making a face out of glass, wire, folded paper, woven straw, inflatable

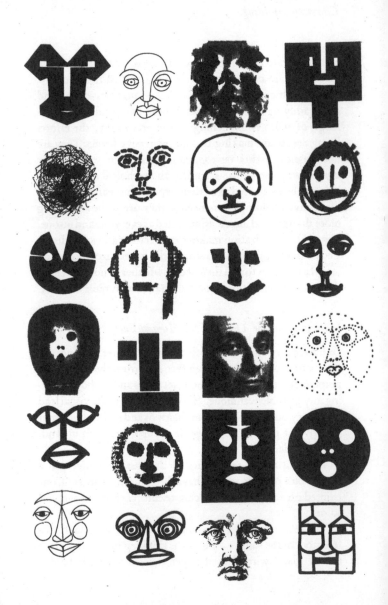

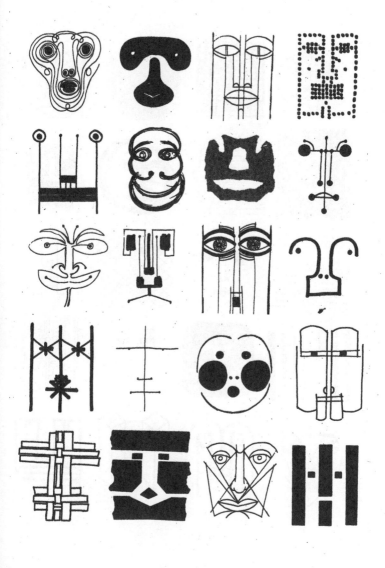

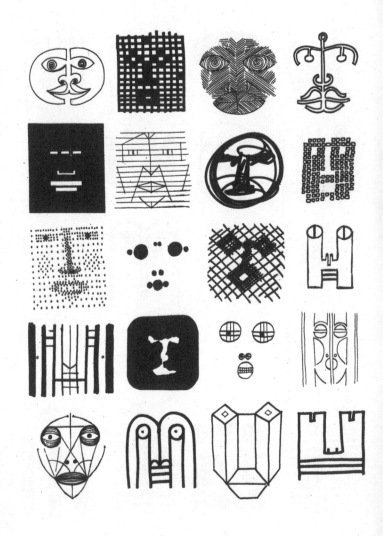

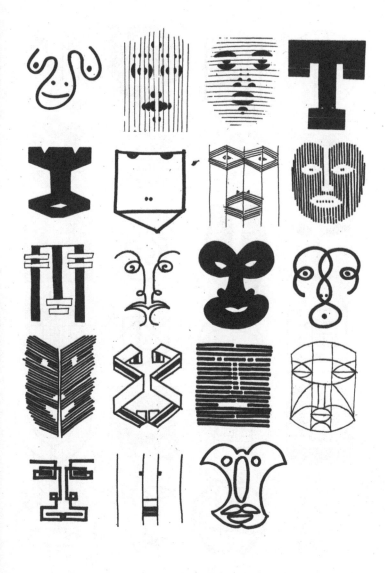

 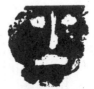

 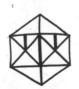

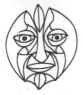

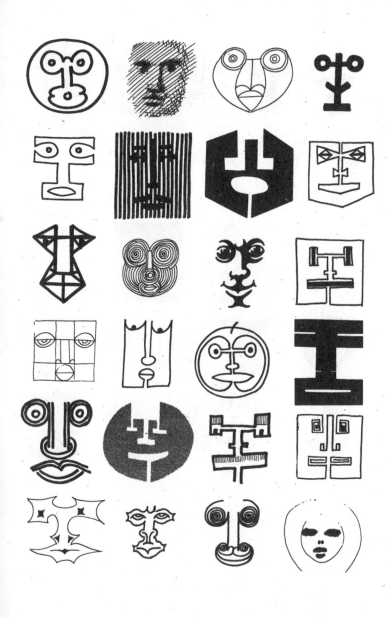

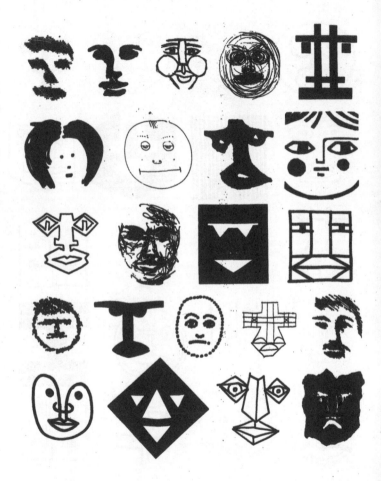

rubber, strips of wood, plastic, fibreglass or wire netting, etc., the relationship between the features will have to be adapted to each material.

Or if we imagine seeing this face through a pane of glass with lettering on it, through a blockmaker's screen, through the slats of a Venetian blind or a bottle full of water, it is clear that we will have a lot of transformations, deformations and alterations of the face. We may also look for all possible linear connections between the features, and we may try to do this with straight lines, curves, dotted lines, parallels, with one unbroken line or with a fragmented one.

For the sake of this exercise we must keep to full-face, for obviously a host of other possibilities arises the moment we go into profiles and all the intermediate stages, or if we use three-dimensional effects or perspective.

Such an exercise as this helps a graphic designer to find the image best adapted to a given theme, and each image and technique has precise qualities of its own and transmits a certain message. A graphic symbol for a cosmetic cannot be the same as one for coal. The graphic designer usually makes hundreds of small drawings and then picks one of them.

The Shape of Words

Not only does each letter of a word have a shape of its own, but all its letters taken together give shape to the word. We are of course referring to printed, or at least written, words; for the words we hear in speech or on the radio do not have a visual form. They have what might be called sonic form, but we are not dealing with this at the moment. When you read the word MAMMA you see at once that it has quite a different shape from the word OBOLO. The lines (straight or curved, upright or at an angle) and the blank spaces between one letter and the next all contribute to giving the word its overall shape.

This is especially the case with words we are used to reading — or forced to read — every day: the names of newspapers, of big firms, foreign countries, film stars, the names dinned into us by assiduous advertisers, words that greet us wherever we look, such as 'sport', and the 'in' words of the moment, such as 'pop'. These we seize at a glance, without having to spell out each letter or syllable. That is, we recognize their overall shape, a thing we cannot do with unfamiliar words such as tetradecapodous or tryanlyonnonodont, especially when these are written in the tiniest print on a minute scrap of paper rolled round a medicine bottle, for example.

Some words, such as the names of well-known firms or products, are so familiar to us that if we block out most of the letters we can still read the name correctly at first glance and

only notice afterwards that something is slightly unusual. But this can only happen if we preserve the general shape of the word.

An experiment anyone can make is to cut out the letters of a newspaper title, for example, and push these closer together until the upright stroke of one letter also does duty for the next. This gives a clearer idea of the shape of the word. One can go even further, and superimpose one letter on another, as in one of my illustrations I have made an M do duty also as an A in the word DAMO (the trademark of an ancient Roman brick factory).

Knowledge of the shape of words and the possibilities these offer for communication can be very useful to the graphic designer when he comes to make warning signs that have to be taken in quickly, like the ones on motorways, that one cannot stop to decipher.

Poems and Telegrams

It is certainly quite wrong to read a poem in a hurry, as if it were a telegram. Though some contemporary poems do in fact have as few words as the average telegram, their content is in many cases different. I say 'in many cases' because one does sometimes get telegrams that might almost be poems, and these one reads through quickly at first and then more slowly, realizing that some of the words can have more than one meaning, as in a poem. They are poems struck off at random. And I will go further and say that each text, however short, has its own 'reading time'. A poem only communicates if read slowly: only then does it have time to create a state of mind in which the images can form and be transformed.

The graphic designer can also operate in this field; where lettering and spacing must be calculated according to the effect required. Though it is commonly done, it is not right to use the same type faces for poems as for the reports of Board meetings. For rapid reading the type must be simple and clear, the spaces between letters and words exactly calculated, the space around each word sufficient to isolate it completely from its surroundings; while the letters and background must not be done in complementary colours.

Quick legibility is the quality required most of all for road-

signs, yet on most of the signs we see the words have com-
pletely lost their shape. For example, the word HULL is
shorter than the word LIVERPOOL, but we often see it
drawn out to H U L L, so as to make it all of a length
with LIVERPOOL. In this way our reading has been
slowed down and the message retarded in the interests of
a quite bogus aesthetic standard.

When we are sitting in an armchair reading a good book
we need to slow down our reading speed, and a number of
writers and artists have realized this need. One of the effects
of the total lack of punctuation in the last chapter of Joyce's
Ulysses is that it changes our reading speed. Klee once wrote
a poem and filled the spaces between the letters with various
colours. The result was that the words revealed themselves to
the consciousness in slow motion. The Futurists composed
their *tavole parolibere* according to this principle, while poems
have also been written with one word on each page. The
reading time of posters is often varied by the use of lettering

of different sizes, and a single word in large letters following ten or twenty lines of small type will be read before the text that precedes it. Some posters and advertisements are read at two or three different speeds.

Onecanalsoeliminatethespacesbetweenthewords: it certainly slows up the reading. But at the same time it is very tiring to the eye.

In some publications that have artistic pretensions the printed text is lined up on the left while the right-hand margin is left ragged. This is done so as not to split the words and create time-gaps in the middle of them. Finally, a good designer could set a text with the reading time varying according to meaning and emphasis, just as a person changes speed in speech. To a certain extent, of course, this is already done with punctuation.

Two in One

Two images in one, or rather an image made up of a lot of other images: such is this illustration advertising rubber spare parts for motor vehicles. The detailed outlines of the individual parts are so arranged as to make up a picture of a car, and taken all together they provide that direct visual information that is the purpose of the advertisement. Not a word of explanation is needed.

Leonardo da Vinci saw trees, towns, battles and a lot of other things in the stains he found on old walls. Shakespeare saw whales and camels in the clouds. Simple Simon looks at the clouds and just sees clouds. The stains on old walls simply look like stains to him. On old walls.

Not everyone sees pictures in the fire, or in the clouds, and of those who do, not all see the same thing. It depends on what they are looking at, and on who is doing the looking.

The shape of a cloud, be it cumulus or cirrus, is already a picture, but sometimes it also takes a form very like an animal or a face or an island. The same thing happens with the grain

of wood or marble, floors made of marble chips, the bark of trees, and in fact all those things that do not have any definite set shape but can take many forms.

It depends on the person looking, because each of us sees only what he knows. If you do not know what a Bunstable is you will never see one anywhere. If, as often happens, a person is exclusively interested in food, then in the clouds at sunset he will see enormous dishes of spaghetti and tomato sauce (if he can raise his eyes from the table to look at the sunset), the clouds will be heaps of mashed potato and in the grains of certain woods he is bound to find pork chops concealed. But joking apart, this business of two or more images in one must be taken into account by the graphic designer when he is trying to achieve really concentrated visual communication. And one can formulate fairly exact rules for it.

We have a historical example in the paintings of Arcimboldi.

Simultaneous superimposed images may for example be useful in a poster showing a hand composed of cigarettes holding a cigarette, when a trademark may be identified with the product, when a watch may be made to look like the sun or moon, and so on.

These double images may either be obvious or concealed. One can present an image with the merest suggestion of another image in it, barely hinted at, so that it is not revealed at once but leaves a trace of doubt in the mind, or allows the second image so ambiguously presented to grow as from a seed in the mind. In such a case the second image works on the subconscious and may well have a more lasting effect, for it seems to the viewer to be a private acquisition, a personal discovery that he has made inside or beyond what was obvious to everyone else.

A Language of Signs and Symbols?

Many of our activities today are conditioned by signs and symbols, though so far these are only used for visual communication and information. Each sign and each symbol has an exact meaning that is recognized the world over: everyone everywhere knows what to do when faced by a certain roadsign. We are already conditioned to doing what these signs tell us to do, and know that we cannot ignore them without being punished. Our movements on the roads are rigorously controlled: we are told how fast we may go, in which direction, whether we take precedence or must wait for others, what lane to drive in and when we may or must stop.

In this case no one may do as he wants to. Each of us is part of the larger organism of human society, and just as in our bodies each small organ must live in harmony with the others, so when we move from place to place we must do it in harmony with others. To neglect the rules is dangerous, because it fouls up the whole organism.

Roadsigns are the best known, but our society has many other signs and symbols for a variety of human activities: the plan of an electric circuit is drawn with a series of conventional signs, meteorologists communicate among themselves with special signs, there are proof-readers' signs and Boy

Scout signs, there are railway signals and the special signs used in railway timetables, on board ship and in factories and workshops. Even tramps use a sign language to tell each other if they can go to a certain place, whether the police are nice or nasty, whether or not they can beg, etc.

In the old days there were the symbols of heraldry, the personal marks of builders and stonemasons, hallmarks on silver and alchemical symbols. Today there are trademarks, internationally accepted signs, the badges of airlines, and so on.

Everyone naturally knows roadsigns because you have to learn them if you want to drive a car. But when the signs used in other fields, such as mathematics and music, are more generally known, then perhaps we may try to express our-selves by means of signs and symbols, and to combine various signs as they do in the ideographic scripts of China and Japan. In these ancient scripts the signs have one value as image or idea when they are alone, and another when they are used in combination. This principle, based on logic, is also used by us in visual communication. For example, in the language of meteorology a six-pointed asterisk means snow, a triangle with its point downwards means a stormy sky. The two together mean 'blizzard'.

In the language of tramps a sign made of two interlocking circles means 'caution', a triangle point upwards with two crude arms raised means 'armed man'. A big triangle with three small ones alongside means that one should spin a really tear-jerking yarn (I imagine that the big triangle is the wife and the little ones her starving children).

In a certain sense the plan of an electric circuit composed of symbols and connections is nothing less than a synthetic discourse of component parts, exact in all particulars and

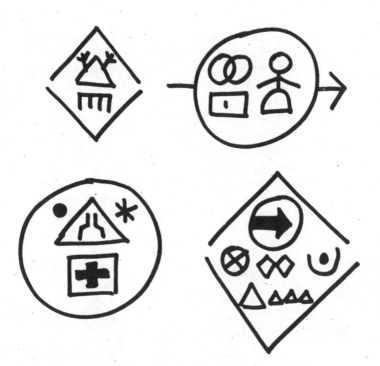

Key to the signs: *top left*, armed man with fierce dog in damp town; *top right*, caution, female danger, proceed this way; *bottom left*, no entry, I am in a narrow place between rain and snow, please help; *bottom right*, friend, this way, good place for begging, go slow, the town is asleep and the police inactive. Tell a tear-jerking tale.

These groups of signs are made up of tramps' signs with a sprinkling of roadsigns.

conveying precise information. It might be put into words in this way: link up with the external power line six feet to the left of the main door, put a fuse in it, connect to the three ceiling lights, put a switch here, a two-pin socket there. . . .

If we suppose all these signs and symbols to be already known to the reader, as they will be in the future, will we be able to write a story that makes sense? A certain elasticity of interpretation is clearly necessary. If I put the sign for 'fuse' between a man and a woman it obviously does not mean that they actually and physically have a fuse between them, but that there is between them a change of tension and a danger

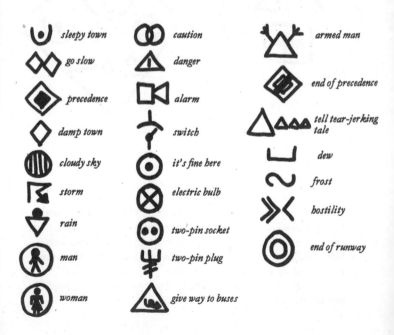

sleepy town

go slow

precedence

damp town

cloudy sky

storm

rain

man

woman

caution

danger

alarm

switch

it's fine here

electric bulb

two-pin socket

two-pin plug

give way to buses

armed man

end of precedence

tell tear-jerking tale

dew

frost

hostility

end of runway

of the circuit blowing. We shall try to use the symbols as the words are used in a poem: they will have more than one meaning, and the meanings will change according to where they are put. We can express the weather with meteorological signs, movement and direction with roadsigns, objects with their appropriate symbols, some sensations in the sign-language of tramps . . . or that of electronics.

The sign for 'switch' may be used to switch off or stop an action, the sign for 'mirage' may have many other meanings, while those for 'precedence', 'stop', 'wait' and 'road narrows' would take on special meanings when used in conjunction

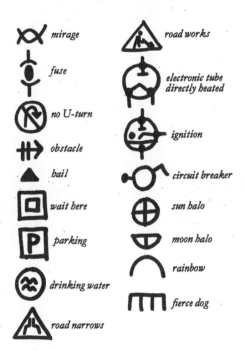

with other signs. The narrative should be clear enough, in some places all too clear, but should also be capable of being as esoteric as a poem.

Will something like this be the international language of the near future? In limited ways perhaps it might. In meteorology and electronics it is already used. But it has not yet been used to tell a story. Or rather, mine is the first attempt.

Attempt at a poem:
 Rain
 on the firing switch
 end of precedence

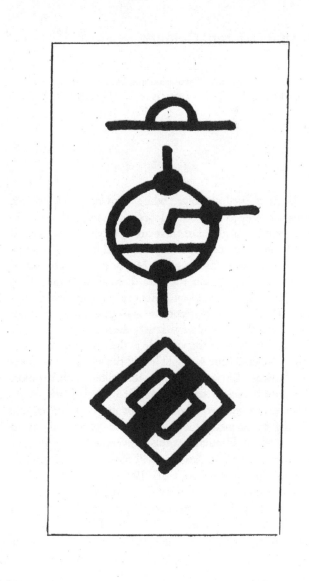

12,000 Different Colours

Colour is nothing but a sensation and has no existence at all independent of the nervous systems of living beings. (*O.N. Rood*)

Red, green, yellow, blue, white, brown, violet, orange, turquoise, grey . . . a list of colours such as this ends almost as soon as it has begun, but there are in fact twelve thousand colours in existence, like cockleshells all in a row. Twelve thousand colours. Think of it. Maybe it is not possible to tell them all apart, but they are there all the same. They exist in the catalogue of an American company which produces plastics, and their purpose is to guarantee a constant production that will always satisfy the needs of the market.

It is true that the list we gave at the beginning was very basic. We could for example list all the various reds, blues and browns. Brown is in fact the colour with the most variations because it can be nearly red, nearly black, nearly green, nearly yellow, nearly blue or nearly grey; for it is nothing but a mixture of all the basic colours (give your child a set of Plasticine strips of every colour in the rainbow, and in half an hour he will have crammed them all together into one brown ball). But even if we named all the colours we can think of we would still not reach 12,000.

There is another American catalogue with a modest 1,200 colours, for use by commercial artists. Each colour is reproduced and numbered. This catalogue might be very useful

for someone planning a large uniform edition of books, for example, or anything else for which one has to use a group of colours which correspond in tone.

How does one arrive at such a vast number of colours? There are various methods. But in the first place we must distinguish black and white from the colours proper, for black and white are no more than darkness and light. If we take, say, a sheet of green paper and look through it at the light we will see a brilliant green. Then let us take it towards a dark corner of the room, and we will watch the green grow progressively darker until in pitch blackness we do not see it at all. If you buy a set of artist's colours it will contain tubes of black and white, but these are used only to make the true colours darker or lighter. So we may in theory set about obtaining a great number of colours in the following way: let us imagine a pure colour, say a red which contains not even the most infinitesimal quantity of yellow, blue or other colour. Take this red, which will be very like the red used by printers in four-colour printing, and paint a disc as big as a penny on a very long strip of paper. Add one drop of black to the red and paint another disc. Then another drop, another disc . . . and so on until the red has turned black. On the same strip, working towards the other end, paint other red discs, but this time progressively lightened by the addition of white, one drop at a time. By the time we have finished we will be extremely tired and our strip of paper will be several miles long. We can then repeat the operation starting with another red, for example with one drop of yellow added to the original pure colour. Then we start with a red with two drops of yellow added. . . .

I am sure that you are prepared to take my word for it and not insist on making the experiment for yourselves to test me

out. You will now realize that twelve thousand colours exist, even if you cannot distinguish one from its neighbour. But the story of colours does not end there. Every colour changes according to the material in which it is fixed, just as in music the same note sounds one way played on a trumpet and quite another when played on the mandolin. Red silk is different from chalk of the same colour, a surface painted in tempera differs from the same painted in oils, one black velvet is blacker than another black velvet. In this case it is the roughness or smoothness of the surface which determines the variation. A smooth surface reflects the light and the colour is more intense, while on a rough surface the colour is matt and more subdued. Mrs Jones is therefore attempting the impossible in trying to match the velvet of her sofa with her sitting-room walls, because the wall is smooth and the velvet is velvety.

Unfortunately people talk of colours too loosely, and create confusions that even those who want to be precise have to adapt themselves to. What colour is white wine? Yellow. But try asking the waiter for yellow wine and all you will get is a pitying look. Do you know what colour a sheet of white paper is? Well, take quite a number of sheets, or open several books and lay them in a row. You will find that some are yellow, some brownish, others grey.

Would it be a good thing if people were taught to know their colours? I certainly think so. Any knowledge of the world we live in is useful, and enables us to understand things that previously we did not know existed.

GRAPHIC DESIGN

Poster with a Central Image

The old idea in advertising was that a poster should hit you in the eye, and even today many people would agree. It is a way of getting information across to the average passer-by, who might well be thinking about the transformation of a caterpillar into a butterfly: a violent transformation, and everyone knows that violence has to be opposed with equal violence.

But joking apart, what did these old-fashioned advertising men mean by hitting you in the eye? They probably meant that a poster must stand out a mile from the other posters displayed around it in the street. It must jump out at you, surprise you, capture your attention by an act of banditry. The same thing goes for all the other posters nearby.

A poster for soap, for example, or for some detergent, must be quite different from any other poster for soap. We already know that a certain detergent washes white, that another washes whiter, that a third washes whiter still, that a fourth washes whiter than the first and second put together, that a fifth washes easily twice as white, and that a sixth (which is in fact the same powder as the one which started the whole idea) washes so white that it makes things look black.

It usually happens that when someone cannot keep his end up in an argument he begins to shout. In this way he does not

add anything new to his argument, but at least he makes himself heard. Many posters want to make themselves heard at all costs, and so they shout with their colours, yell at you with strident shapes. And the worst thing of all is that there are

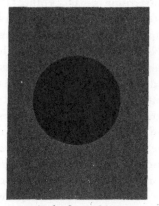

Basic pattern of a poster in the form of the Japanese flag. The eye is attracted by the dark disc and has no way of escaping. It has to tear itself away. The space around the disc isolates the image from any other near-by forms.

thousands of them all bellowing at you in satanic discord. Not having studied the exact techniques of visual communication, advertisers fall back on commonplace images which they multiply *ad nauseam* and without thinking whether the forms and colours they are using could not equally well be applied to tyres, soap or apéritifs. But the designer's experiments have taught us that it would be enough to employ an unusual colour, a different form, and to give the passer-by exact and immediate information instead of assaulting him time and time again until he is battered senseless.

On the other hand one sometimes sees posters so jaded

they seem to have been deliberately camouflaged, and it is incredible that they could have been accepted and printed. It probably happens like this. The painter (not a graphic designer) makes a rough sketch of the poster and takes it along to the advertising manager's office. This sketch is full size, say three feet by five, and done on canvas or stiff paper. It is propped up opposite the advertising manager's desk for his approval. Now his office is furnished with exquisite taste, as befits the head of a department: for one must not only be the head of a department, but must be seen to be such. The colours are muted, the furniture of a classical restraint. There is nothing in the least gaudy about it. In these surroundings the poster, even if it is ugly, has an explosive force. The picture hanging on the wall beside it looks like a washed out photograph. The poster is accepted and printed, and only then is it realized that surrounded by a mass of other posters it is barely noticeable. But what's done is done, and all we can hope is to do better next time.

There is one basic kind of poster that graphic designers often use, because it is so visually compelling. This is the Japanese flag, a red disc on a white background. Why is such a simple design so effective? Because the white background isolates the disc from everything around it, from the other posters, and because the disc itself is a form that the eye finds it hard to escape from. The eye is in fact accustomed to making its escape at the points or corners of things, at the head of an arrow for example. A triangle offers three escape routes, a square offers four. A circle has no corners, and the eye is forced to go round and round in it until it tears itself away with an effort.

How is this basic pattern used in a poster? The disc may represent or become a tomato, a plate of soup, a clock, a foot-

ball, a shell, a steering-wheel, a cooking pot, a round cheese, a button, a champagne cork, a gramophone record, a flower, a roadsign, a wheel, a tyre, a target, a ball-bearing, a Gothic rose-window, an open umbrella, a cogwheel . . . and last but not least the globe. A photo of a globe, the globe painted with bold strokes of the brush, a globe made of strips of paper or torn paper scraps, in black and white, in colour. . . .

Even today you will find this basic design used for countless posters.

On the other hand it is a mistake to divide the surface of a poster into different blocks of colour or print. Such a poster fades too easily into its surroundings, and each part of the composition flows off into the poster next door, confusing the public and absolutely nullifying the effect of the message.

Basic pattern of a poster cut up into separate sections. The eye wanders over the surface and is continually forced to follow the dividing lines between the light and dark sections. These lead it out and away from the poster. Besides this, the sections themselves may easily seem to belong to the posters next door.

Poster without End

Is it possible to make a poster of unlimited dimensions, a poster as long or high as you care to make it? A poster three foot by five, twelve foot by two and a half, six foot by ten . . . ?

Posters are usually designed as single entities, enclosed within their particular dimensions, and then pasted up on walls and hoardings three or four together and sometimes more. Now it often happens that a poster is simply not designed to be displayed side by side with its twin, and some very odd things may happen to the form if it is so displayed. If (as in a recent example) two faces in profile are looking into the poster from right and left, sniffing at the soup or exclaiming over the apéritif that occupies the centre of the design, when several of these posters are put up together the result is a series of strange Janus-faced creatures looking both ways at once, an image that was far from the mind of the designer. Every figurative element of the poster that is cut by the right- or left-hand edge will inevitably combine in some unforeseen way with the poster next door. This never happens to posters with a central image, as described in the last chapter.

But there is a way of getting round this problem, and this is the method already used for designing wallpaper and materials for clothing and furnishing. Here the left hand side must know what the right hand is doing, the top must know the bottom. If some form is cut in half by the right-hand margin, then the left-hand margin must have a corresponding form for it to link up with, for the right of one poster joins on to the left of its neighbour.

It is therefore in certain cases possible to design posters on the same lines as wallpaper, posters with no set limits, that can be pasted up on a wall by the dozen to form one great poster of any size you like.

An Italian example of this – but of a product sufficiently well known to English readers – is the Campari advertisement displayed in underground stations. It is hard to say for sure whether it is one poster or many. The red background holds the whole thing together, while the name of the product is cut to pieces and put together again in such a way as to make an endless game for the eye. Meanwhile the impression of depth is conveyed by printing the word CAMPARI in bigger or smaller letters. The eye is attracted by this interplay of various combinations, and runs easily back and forth (often in the malignant hope of finding a mistake somewhere). This poster gets across its message even if you just catch a glimpse of it, if people are standing in front of it, or if you pass it in a train at speed. In this particular case the series can only run horizontally, but clearly it is also possible to make posters combine vertically as well. The motif which links one poster with its neighbour can also be quite distinct from the thing advertised. For example, one might put a red apple on a background of black and white check or horizontal lines, or have a coloured band running right through the series of posters and bearing the overprinted name of the product.

The edges of a poster are therefore worthy of special consideration. They may serve as neutral areas to isolate one poster from the others around it, or as calculated links in a series. In any case one can never ignore them when one designs a poster, and certainly not if one wants to avoid the unpleasant surprise of seeing one's work come to nothing the moment it goes up on a wall.

Trademark of the 'Nobel Prize' editions, devised with reference to old Byzantine, Christian and Greek writing. Various working

THEODORES II

stages are visible in this sketch, as well as tests of legibility. The graphic form is contained within two squares. Such a mark must be legible even if reduced to the smallest proportions.

the sky is ripe

gnee

the dustbin snake

S and Z

Children's Books

Knowing children is like knowing cats. Anyone who doesn't like cats will not like children or understand them. Every day you see some old woman approach a child with terrible grimaces and babble idiocies in a language full of booes and cooes and peekiweekies. Children generally regard such persons with the utmost severity, because they seem to have grown old in vain. Children do not understand what on earth they want, so they go back to their games, simple and serious games that absorb them completely.

To enter the world of a child (or a cat) the least you must do is sit down on the ground without interrupting the child in whatever he is doing, and wait for him to notice you. It will then be the child who makes contact with you, and you (being older, and I hope not older in vain) with your higher intelligence will be able to understand his needs and his interests, which are by no means confined to the bottle and the potty. He is trying to understand the world he is living in, he is groping his way ahead from one experience to the next, always curious and wanting to know everything.

A two-year-old is already interested in the pictures in a story book, and a little later he will be interested in the

story as well. Then he will go on to read and understand things of ever increasing complexity.

It is obvious that there are certain events that a child knows nothing of because he has never experienced them. For example, he will not really understand what it means when the Prince (very much a fictional character these days) falls in love with the equally fictional Princess. He will pretend to understand, or he will enjoy the colours of the clothes or the smell of the printed page, but he will certainly not be deeply interested. Other things that a child will not understand are: de luxe editions, elegant printing, expensive books, messy drawings, incomplete objects (such as the details of a head, etc.).

But what does the publisher think about all this? He thinks that it is not children who buy books. They are bought by grown-ups who give them as presents not so much to amuse the child as to cut a (sometimes coldly calculated) dash with the parents. A book must therefore be expensive, the illustrations must use every colour in the rainbow, but apart from that it doesn't matter even if they are ugly. A child won't know the difference because he's just a little nincompoop. The great thing is to make a good impression.

A good children's book with a decent story and appropriate illustrations, modestly printed and produced, would not be such a success with parents, but children would like it a lot.

Then there are those tales of terror in which enormous pairs of scissors snip off the fingers of a child who refuses to cut his nails, a boy who won't eat his soup gets thinner and thinner until he dies, a child who plays with matches is burnt to a cinder, and so on. Very amusing and instructive stories, of German origin.

A good book for children aged three to nine should have a very simple story and coloured illustrations showing whole figures drawn with clarity and precision. Children are extraordinarily observant, and often notice things that grown-ups do not. In a book of mine in which I tried out the possibilities of using different kinds of paper, there is (in chapter one, on black paper) a cat going off the right hand edge of one page and looking — round the corner, as it were — into the next page. Lots of grown-ups never noticed this curious fact.

The stories must be as simple as the child's world is: an apple, a kitten (young animals are preferred to fully grown ones), the sun, the moon, a leaf, an ant, a butterfly, water, fire, time (the beating of the heart). 'That's too difficult,' you say. 'Time is an abstract thing.' Well, would you like to try? Read your child the following paragraph and see if he doesn't understand:

Your heart goes tick tock. Listen to it. Put your hand on it and feel it. Count the beats: one, two, three, four. . . . When you have counted sixty beats a minute will have passed. After sixty minutes an hour will have passed. In one hour a plant grows a hundredth of an inch. In twelve hours the sun rises and sets. Twenty-four hours make one whole day and one whole night. After this the clock is no good to us any more. We must look at the calendar: Monday, Tuesday, Wednesday, Thursday, Friday, Saturday and Sunday make one week. Four weeks make one month: January. After January come February, March, April, May, June, July, August, September, October, November, December. Now twelve months have passed, and your heart is still going tick tock. A whole year of seconds and minutes has passed. In a year we have spring, summer, autumn and winter. Time never stops:

the clocks show us the hours, calendars show us the days, and time goes on and on and eats up everything. It makes even iron fall to dust and it draws the lines on old people's faces. After a hundred years, in a second, one man dies and another is born.

with four books

Variations on the trademark of the *Club degli Editori* (Publishers' Association), the emblem being a fish. These sketches were made to see how far it can be changed and still remain recognizable. In some kinds of advertisement or in setting up stands at exhibitions, for example, the trademark is sometimes a wooden construction several yards high. Will it still be recognized as such? In what ways can it be varied without essential change? At the bottom left is a photo of four books stood on edge and opened in such a way as to form the trademark. This idea was actually used in an advertisement.

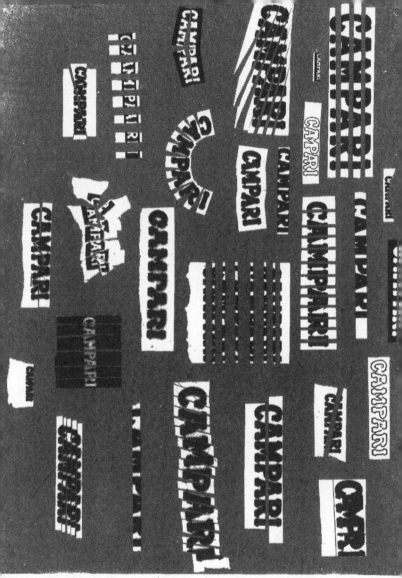

Exercises in altering and deforming a well-known brand name until it reaches the limits of legibility.

INDUSTRIAL DESIGN

Micro-Art

All the objects that surround us in the home or at our place of work are tending to become smaller and smaller without getting any less effective or functional. Apart from things which have contact with our bodies (chairs, beds, etc.), everything is on the way to becoming miniature. A radio set ten years ago was an affair as big as a sofa, but now thanks to transistors and printed circuits we can easily carry our radios about in our pockets. The archives in which documents are stored used to occupy vast halls with dusty shelves stretching from floor to ceiling. Today the whole lot are down on a microfilm that will fit into an ordinary desk drawer.

One of the smallest electronic computer cells is one made in Germany. It is square in shape and each side is two millimetres long. It contains 15 silicon transistors and 13 resistors with their relative connections. In a thousandth of a second it can store complex information running into several figures.

Automatic microfilm can be made as fast as a thousand frames a minute. Each photograph can then be enlarged again on to paper in a few seconds and at very little expense. The use of this system cuts down the space needed in archives by ninety per cent. The film is specially made so as to last for many years without deterioration.

Everything changes for reasons of economy: the less room

things take up, the smaller the expense. And for the same reason attempts are being made to build houses that are smaller than in the past, but just as comfortable. Those great houses with their sky-high ceilings and broad dark corridors, those huge villas in their private parks, are slowly disappearing. They are having a last flicker of life at the moment thanks to film stars and others who have made a lot of money very quickly and don't know how to spend it all.

The private house of the future (some are already lived in) will be as compact and comfortable as possible, easy to run and easy to keep clean without the trouble and expense of servants. A lot of single pieces of furniture will be replaced by built-in cupboards, and maybe we shall even achieve the simplicity, the truly human dimensions, of the traditional Japanese house, a tradition that is still alive.

The living-room of our new house will perhaps have one wall made completely of glass, another devoted to built-in cupboards, one blank movable wall and a fourth wall with the door in it. The floor will be carpeted, the ceiling low but luminous, and there will be chairs and surfaces for putting things on. In the old-fashioned house there were countless walls hung with pictures, and the corridors were wide enough in places to stand statues in. But in the new house there is no longer any room for this kind of art. A picture is already but a portable version of a frescoed wall. Does anyone nowadays have the walls of his house frescoed? Just about no one, I should think. This is not so much on account of any technical difficulty, but because we move house so often: at least we can take our pictures along with us. But how in the future is a collector going to find room for all his works of art? Will he keep them in a special storeroom? And when we come right down to it, are painting and sculpture as we know them

today the only ways of creating visual art? Can we not find other creative means?

What happened in music when people realized that the times had changed and that no one any longer summoned orchestras to their houses to play them concerts? Why, records and high-fidelity equipment. An orchestra in the drawing-room belongs to the age of frescoes. Today we have techniques whereby artists can make works to be projected, tiny compositions with colours that change by means of polarized light or fixed-colour slides made of plastic.

Once upon a time an artist's colours came in tubes. Now, for those who know how to use them, there are the new possibilities created by hundreds of different materials and colours that come in sheets. In the house of the future, reduced as it will be to minimum size but equipped with the most practical gadgets, we will be able to keep a thousand 'pictures' in a box as big as a dictionary and project them on our white wall with an ordinary projector just as often as we please. And I do not mean colour photographs, but original works of art.

With these techniques visual art will survive even if the old techniques disappear. Art is not technique, as everyone knows, and an artist can create with anything that comes to hand.

One day a man with nothing but a hammer in his hand presented himself to one of the great personages of the day and said: 'With this hammer I intend to make works of art, great works that the whole world will come flocking to see.' They ushered him, kindly but firmly, out of the palace. It was Michelangelo.

How One Lives
in a Traditional Japanese House

We have never grown tired of each other, the mountains and I.
(*Li-Po*)

Ever since I was a boy I have dreamt of living in a Japanese
house made of wood and paper. During a recent trip to Tokyo
and Kyoto I stayed for three days in a traditional house and
was able to poke around and notice every detail, the thick-
nesses, the materials, the colours. I was able to sniff around
it inside and out, and try to make out how it was built the
way it was, and why.

In modern Japan there are thousands of buildings and
great office blocks made of cement, but the house that people
actually choose to live in is nearly always the traditional
house of wood, straw and paper.

The entrance of this very ancient type of house is most
discreet. One does not step straight from the street into
the living-room, as we so often do. There is a space, nearly
always a small space, between the street and the door. It
may be six foot square, this space, but it is enough to create
a sense of detachment that is, I should say, more psycho-
logical than physical. The surface of these four square yards
differs from that of the street. If the street is asphalt, this
tiny forecourt will be paved with stones, and not just slabs
of paving but stones of different kinds. Then there is one
wall made of bamboo, one of natural wood, and one

stuccoed. The street side of the forecourt sometimes has a low wooden gate. In some cases there is also a small trickle of water running in a groove or a square stone with a round hollow full of water in it. Our equivalent would be the gutter that you see sticking out of the side of certain peasant houses, that periodically gushes out soapy water from the wash tub.

A small tree rather higher than the bamboo wall throws a decorative pattern of leaves on the plastered wall. The actual door is hidden behind a screen of dry branches. One opens the door and there one is. The entrance hall is paved with rough grey stone, and there one takes off one's shoes. On a wooden step one finds a pair of slippers. The room one enters next is raised above the level of the hall. If you go to Japan don't bother to take a pair of slippers: anywhere you go you will find some ready for you.

Our custom, on the other hand, is to keep our shoes on and trample the dirt from the street right through to the bedroom.

The character of the inside of the house is determined by the *tatami* on the horizontal plane, and by other vertical modular components. The module, prefabrication, mass-production and all the other things we are now recommending as necessary innovations have been used for hundreds of years in the traditional Japanese house.

The *tatami* is a mat of fine and tightly woven straw, and its colour is that of almost dry grass. It is edged with dark (often black) material and its size is about three foot by six, the size of a man lying down. The floors are covered with these *tatami* from wall to wall. They are pleasantly soft underfoot. The proportions of the room are expressed in *tatami*, so that a two-*tatami* room is about six foot by six, an eight-*tatami* room is twelve by twelve, and so on.

Another Japanese discovery that we are now in the process of discovering is the moving wall and the continuous window. All the inside walls of the Japanese house are movable except those devoted to built-in cupboards. Similarly, with the exception of the household services, all the rooms have outside walls that slide. One puts the walls and windows where one wants them. According to the position of the sun or the direction of the wind, one can arrange one's house in various ways.

I should tell you at once, in case you do not know, that there are no pieces of furniture stuck about the room. Everything one needs is kept in the wall-cupboards, that also act as soundproofing when necessary. Even the bed (that is, mattress and blankets) is kept in one of these cupboards. When you want to go to bed you close one wall, take your mattress out of another, lay it on the *tatami* (which is by no means 'on the ground', as some people think), tuck the blankets round it and go to sleep. And how do you sleep? Very well indeed. The floor is not hard or cold, thanks to the *tatami*, and the mattress gives one the firm comfort of a good solid bed without a sagging hole in the middle.

The rooms are about eight feet high, so that when one lies in bed there is not a great yawning void above one. It is like being in a large four-poster.

The sliding doors of the house itself and of the cupboards are made of paper mounted on a light wooden frame, and they run in grooves scarcely wider than a scratch between one *tatami* and another. They are so light they can be moved with a fingertip, and they have no locks or handles.

But we of course have heavy doors with locks and handles, bolts and chains, and when we shut our doors the bang can be heard all over the house. But when you shut a paper door. . . .

One pads softly over the *tatami* in one's socks, the light is discreet but sufficient, the proportions are harmonious. Air is circulated in a natural way. Instead of blasting in 'conditioned' air that is nearly always either too hot or too cold, the Japanese have regulable openings in the coolest part of the house and others at high points in the sunniest part. In comes the cool air and out goes the hot air. In winter they simply make their rooms small, so that a brazier or small stove gives ample heat.

The 'windows' are sliding frames fitted with paper or glass, and they can be opened all round the house. They are protected by a roof that projects so far as to form a covered way along the outside. This serves as a kind of veranda, or an external passage between one part of the house and another. Windows and doors, you will already have realized, are one and the same thing. Each panel could equally well be thought of as either.

The building materials are used in their natural state and according to logical and natural rules. For example, what should one use to roof a wooden house, as we would use tiles? A layer of cypress bark of course, for bark is the part of the tree accustomed to alternations of sun and frost, damp and drought, so it will not rot or perish. In using wood for the rest of the house it is always borne in mind that every tree-trunk has a back and a front: the front is the part facing the sun, the back is the shady side. They do not put wood that has always been in the shade in a sunny part of the house, or vice versa.

All woods and other materials are thus used in their natural state, and only for certain exceptional uses are they painted. A natural material ages well. Painted material loses its paint, cannot breathe, rots. It has become bogus.

All these houses, whether rich or poor, have the same modules, the same *tatami*, the same woods and the same proportions, but they differ in the degree of inventiveness with which the materials are used. Their colour is neutral, ranging from grey-green to walnut, from the colours of the woods to those of dry grasses, and finally that of a special stucco coloured with the clay soil of Kyoto.

In such natural surroundings a person stands out and dominates. Sitting on the *tatami* or on cushions at a small low table – the only piece of furniture and the only lacquered object of any kind – one drinks tea and plies one's wooden chopsticks. The food is simple and abundant, a kind of oriental equivalent of Tuscan cooking. The wine is *sakè*. At the end of the meal the chopsticks are thrown away, the few plates are washed and put away, and the dining-room becomes the sitting-room again. Later on it will be a bedroom. There is no moving of furniture, no complication, no clattering of knives, forks and spoons. Everything is of the simplest.

In the part of the house which is most used there is a kind of square niche with a raised floor. This is the *Tokonoma*, a corner of the house made out of materials from the preceding house, a link with the past. It is sufficient that in our new house we have an old wooden post, well seasoned but still sound. In the *Tokonoma* is the only picture hanging in the house (there are others rolled up in the cupboards), and a vase of flowers arranged with real art. Unlike us, the Japanese do not buy a couple of pounds of carnations and stuff them into the first jam-jar that comes to hand.

Even the 'services' are arranged with simplicity and imagination. From the lavatory window one can see a branch of a tree, a patch of sky, a low wall and a hedge of bamboo.

The bathtub is made of wood, the most pleasant material to the touch.

Of course, living in a house made of paper and wood one has to behave well. One must learn not to lean against the walls, or throw cigarette butts on to the floor. One cannot bang doors and spill things. But if by chance one does dirty a door, with a few pence one buys a new piece of paper and all is spick-and-span again.

How lucky we are, in comparison. Especially in Italy where our floors are made of marble, which doesn't burn, so we can drop our cigarettes on to them without even having to stamp them out, where we can slam the doors to our hearts' content (otherwise they don't shut properly), where our hands can swarm here there and everywhere and we can make crazy patterns on the wainscot with the soles of our shoes. And as if that weren't enough we try to use materials that won't show the dirt. We do not get rid of dirt, or try to behave in a more civilized way. Just as long as we don't see it, why worry?

Anyone wishing to study this subject more closely is recommended to read the fine volume on Japanese architecture by Teiji Itoh, published in Italian by Silvana.

What is Bamboo?

It is very interesting to the designer to know what bamboo means to the Japanese, how they grow it, use it, work it, eat it. Especially interesting is the way that Japanese craftsmen, those few who are still willing to earn little in order to do a job that really satisfies them, set to work on this material. Bamboo is a wood that is almost like bone, a kind of prehistoric grass (I must remember to ask a botanist if it dates from the era of the giant ferns), a plant that in the right conditions can grow as much as eight inches a day.

The straightness of bamboo fibres is probably the result of this phenomenal rate of growth. Bamboo is almost like a vegetable extruded section, a smooth green tube blocked on the inside every so often. Corresponding with the inner blockages there are knuckled rings on the outside that seem to mark the pulses of the plant's rhythm of growth. Nature provides bamboo in all sizes, and (for no extra charge) already painted.

The Japanese have since time immemorial used bamboo to make tubes, simply by breaking through the blockages with thin iron rods. They use it for the framework of houses, they make fences out of bamboo rods tied together in a thousand different ways, they make vases for flowers, using the block-

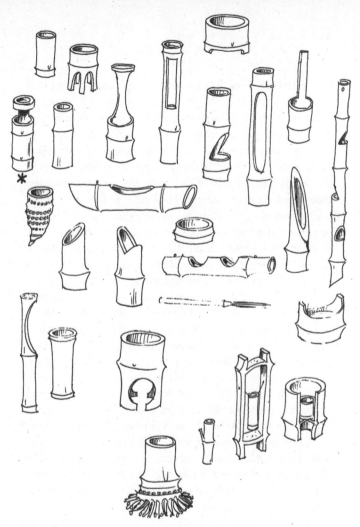

A few of the many kinds of vases made of bamboo. The one on the left, marked with an asterisk, is one of the most ancient types of vase for Ikebana (the art of arranging flowers) and is the work of Sen-no-Rikyu (mid sixteenth century). It is just over thirteen inches high, and was used in the tea ceremony.

age as the bottom of the vase and cutting the bamboo into the most unimaginable shapes. These vases are excellent examples of the skill and inventiveness of Japanese craftsmen. They always pay attention to the nature and structure of the 'tube with knots in it', and discover in it a great variety of proportions. There is always a perfect balance between the inside and outside of the vase, and also between the masses and the empty spaces. The knot is always placed in its logical position, just where one would expect a good designer to place it if he were working with this material.

I have seen a moneybox made of a single piece of bamboo closed by a knot at either end and a slot for coins; a pair of stilts with poles and foot-rests made entirely of bamboo; a syringe made of a piece with a knot at one end, a fine tube of bamboo inserted in the closed end, and a piston made of a third tube whose outer diameter exactly fitted the inner diameter of the cylinder. I need hardly mention fishing-rods, javelins and other sports equipment, musical instruments, toys and gadgets of every kind. I have even bought paint-brushes made entirely of bamboo: there is a knot at one end of the handle, while the other end has been frayed out into thread-like fibres. It can be used like a normal bristle brush.

If one splits a six-foot-long green bamboo cane length-wise, using a blunt knife, one obtains two equal halves. The knife is guided by the fibres, and the stuff splits at once. One can go on repeating this until one has dozens of bamboo threads six feet long and perhaps only a millimetre thick. They use these threads to make rolling shutters, mats, baskets, and all the things that we tend to make out of rushes or wicker.

Larger strips are used for other kinds of mats, baskets, etc. Then, if you split a bamboo cane in two and lay the

halves on the ground with the open sides downwards, you have only to tread on them and they fan out into four or six segments to form a flat surface. In this way the Japanese make walls, ceilings, and many other parts of their houses.

Japanese craftsmen cut and work bamboo completely naturally and almost without the use of special tools. The things they make are immediately comprehensible because the material has been used according to its inherent nature; it is natural and logical that the diameter of the cane should be greater at the knots, and it appears equally logical that any cuts should be made in a precise way, according to the use of the object.

I will not say that all Japanese craftsmen are good, but most of them are. They have tradition behind them. Of course there are also those who ape Western styles, using bamboo for 'abstract' decorations that might just as well have been made out of plastic tubing. Such workmen simply show their lack of intelligence.

When one studies something characteristic of a people it is wise to look at its best side, at least if one wants to learn anything. Ugly things are ugly in much the same way the world over. Only the best can teach us, and the best of anything is individual. Each country excels in some things, and in the rest is just the same as other countries: mediocre.

A Spontaneous Form

... Or perhaps I might say a natural form. Nature in fact creates her forms according to a particular material, function, environment and set of needs. Simple forms such as a drop of water or more complicated ones such as the praying mantis are all made according to laws of structural economy. In a bamboo cane the thickness of the material, the decreasing diameter, the arrangement of the knots and the elasticity of the cane answer to exact laws of economy. It would be all wrong if it were bigger at the top than at the bottom. If a cane were more rigid it would break, if it were more pliable it would bend under the weight of the snow. Errors of construction do not arise from the aesthetic aspects of a thing, but from neglect of the natural and logical techniques of construction.

It therefore seems that a thing made with precision is also beautiful, and the study of natural and spontaneous forms is of the highest importance to the designer, whose habit it is to use materials according to their nature and their technical characteristics. He does not use iron where wood would suit better, or glass when the logical thing would be plastic.

The designer of course does not operate in nature, but

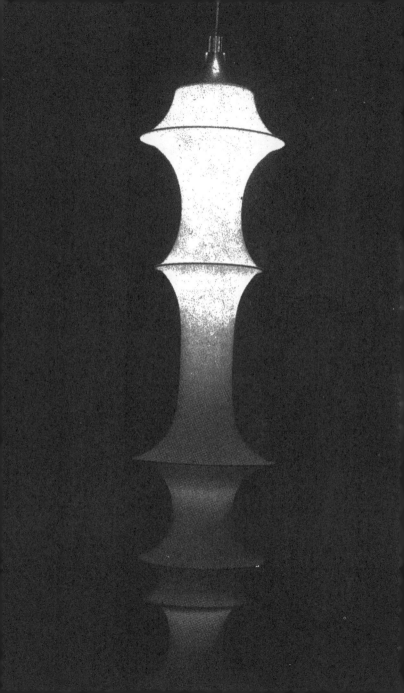

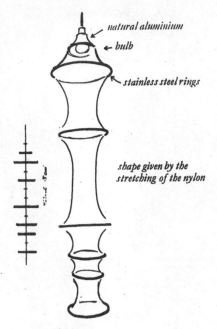

natural aluminium

← bulb

stainless steel rings

shape given by the
stretching of the nylon

*tube-like light
fitting made of nylon net – 1.60 m. high*

within the orbit of industrial production, and therefore his projects will aim at a different kind of spontaneity, an industrial spontaneity based on simplicity and economy in construction. There are limits of how far simplicity of structure can be taken, and it is exciting to push things to these limits. One sees how many different imitations are made of a spontaneous object, all inferior to the original, as if they were preliminary studies made in the course of arriving at the simple form.

An example of a spontaneous form is the lamp illustrated here. Basically it is a simple tube of artificial fabric as used

for stockings. For a long time I had been thinking about elasticity as a formal component of things, and one day I went to a hosiery factory to see if they could make me a lamp. 'We do not make lamps, sir. Only stockings,' they said. I told them to wait and see.

Manufacturers sometimes have fixations. They impose limitations on themselves. They think that their product can only be used for one particular type of goods. But with experiment and good will one can think of new things to make, and so enlarge the commercial possibilities of a given product.

So it was in this case. The factory gave me all the necessary information about the maximum and minimum elasticity of stocking materials, the sizes in which it was possible to make the tubes, the best kinds of thread to put to this new use, and lastly a sample piece of white tubing, of a size decided on the spur of the moment, for me to experiment with.

The formal components of the lamp are as follows: the elasticity of the material used, the tension provided by metal rings of various sizes (the largest corresponding to the maximum elasticity of the tube), and the weight.

The spontaneous form is born from these three factors, which are all closely related one to another. The object literally makes itself by creating a balance between these forces.

Thus it turns out that the flexible section between one ring and the next has the natural quality of a piece of bamboo, for example, but without trying to 'represent' the bamboo or remind us of the small geometric structures of soap bubbles. It is simply itself.

One problem that arose was how to attach the metal rings, and this was solved by making loops in the material

itself. These loops made it easy to find the right place for the rings when it came to putting the thing together, and also ensured that the rings were parallel to one another.

When hung up the lamp is about five foot high, but you only have to put it down on a flat surface and it collapses to a height of scarcely more than an inch. Storage and postage are therefore no problem, and costs are thereby cut. To obtain the form, one simply has to hang the thing up. There are no struts or other fittings to hold the rings in place, as there are in all table lamps designed according to preconceived stylistic or formal ideas. The form really does emerge spontaneously, in this case from our experiments with materials and tensions.

The rings are so placed that the light from the bulb at the top reaches to the very bottom, giving the effect of silk *moiré* as one looks through the layers of fabric.

A Prismatic Lamp

From the moment he sets about a job a good designer must bear in mind that an object that takes up quite a lot of room when in working order must not be bulky for storage or delivery. By saving on storage and delivery costs he is cutting the eventual sales price of the product.

Many designers make things that can be assembled and dismantled, but a lot of slots and screws make life difficult for purchasers who are not accustomed to them. The ideal would be for objects to assemble themselves automatically the moment they are unpacked, like the huge things a conjuror draws out of his little box: out of a flat box comes a three-dimensional object.

In many cases this is possible. It is enough to count the force of gravity as one of the components of an object. An old-fashioned chandelier without its frame at once becomes a pile of rubbish. Its form is obtained with the help of gravity.

The luminous prism illustrated here is designed on these principles. It is made of three sheets of polyester and fibreglass attached to a simple articulated frame. In its box in the storeroom it is less than an inch thick, but take it by the ring at the top which fits round the light-socket, and it will pull itself into shape by its own weight.

The three transparent sheets are held together by rings that are also attached to three thin aluminium rods. These rods are attached at the light-socket end by other rings. The whole thing is articulated and folds easily, and the corners of the otherwise square sheets are cut off to make this even easier.

The material has a luminous beauty of its own when lit

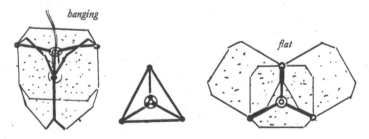

hanging

flat

up from inside. When it is folded, it can be safely and cheaply sent through the post.

Subtract rather than add: this rule must be understood in the sense of reaching simplicity, getting at the essence of the object by eliminating anything superfluous until no further simplification is possible.

Wherever possible one must make a choice of materials for the object and also a choice of techniques. For example, makers of motor-car bodies still produce thousands of parts and useless refinements simply to please the questionable taste of the public. The money they spend to gratify this taste (which apart from everything else changes each season) could be spent on making this worship of an ephemeral kind of beauty into a stable appreciation of authenticity. This would reduce production costs and lead to a simpler and more genuine product. An object stamped out in one piece, with the minimum of working hours needed for finishing, is the ideal that a designer ought to work towards. Clearly it will not be long before car bodies made of single pieces of plastic will replace the complicated ones now made up of many pieces, all pressed separately and then welded together.

By designing without any stylistic or formal preconceived notions, and tending towards the natural formation of things, one gets the essence of a product. This means using the most appropriate materials of the correct thickness, reducing working hours to a minimum, combining a number of functions in one element, making all attachments simple, using as few different materials as possible for each single object, trying to abolish the need for finishing off in detail, doing any necessary lettering during the original pressing, and bearing in mind that the object should take up as little storage space as possible and should assemble itself automatically when ready for use. As for this last effect, one should, when possible, use the force of gravity, remembering that a hanging object costs less than one standing up. These are only some of the tricks of the trade which an experienced designer finds useful for coping with problems as he goes along.

rubber sleeves

Some studies made of the structure and possible variants of a cubic lamp. The problem is to hold a cube of plastic open with wire supports running horizontally along the diagonals and vertically on the four upright sides.

Wear and Tear

Go into the kitchen and open the first drawer you come to and the odds are you'll find the wooden spoon that is used to stir soups and sauces. If this spoon is of a certain age you will see that it no longer has its original shape. It has changed, as if a piece had been cut obliquely off the end. Part of it is missing.

We have (though not all at once, of course) eaten the missing part mixed up in our soup. It is continual use that has given the spoon its new shape. This is the shape the saucepan has made by constantly rubbing away at the spoon until it eventually shows us what shape a spoon for stirring soup should be.

This is a case (and there are many) in which a designer can learn what shape to make the object he is designing, especially if it is a thing destined to come into frequent contact with other things, and which therefore takes its particular shape according to the use to which it is put.

What could be more utterly wrongheaded than the heel of a shoe? Upon this we put the whole weight of our bodies while standing or walking. As soon as we actually use these heels we destroy them, yet we obstinately persist in putting identical heels back on again. These are heels made to be

admired in shop windows, while the shoes are as useless and as stationary as pieces of sculpture. Certain children's shoes are now made with rounded heels, and start out in the shape that wear will reduce them to anyway. But this is impossible for grown-ups. Such shoes wouldn't sell. They're not dignified.

In some cases wear demands the opposite solution: instead of going along with it we must oppose it. A motor tyre is thickest where it will take most wear. We must therefore consider the question of wear carefully. One cannot generalize and make one rule that holds good in all cases.

If you have visited the famous Leaning Tower of Pisa, have you noticed how the steps are worn? The angle of the tower makes you climb on the inside of the spiral staircase when the wall is leaning inwards, and move over to the outside edge when the wall slopes outwards.

The result is a strange helicoidal groove that has no particular lesson to teach the designer but is interesting simply as a fact, as a groove worn by thousands of pairs of feet, all following a pathway forced on them by the angle of the tower. In an upright tower the groove would be somewhere between the middle of each step and the inner edge. In any case it would run parallel to the outside edge of the staircase. But in the Leaning Tower it is by no means parallel. Suppose we laid all the steps in the tower side by side on that wonderful green lawn of the Cathedral Close, in the order they are in now but flat on the ground, we would see the groove winding its way from side to side of the line of stone.

But enough of that. Let's put them all back in the tower again.

Orange, Peas and Rose

Can one draw a parallel between the objects created by a designer and those produced by nature? Some natural objects do have elements in common with the products of the designer's craft. What is the rind or shell of a fruit if not the 'packing' it comes in? Different fruits, from coconuts to bananas, are packed in different ways. Perhaps if we apply the jargon of design to a few natural objects we may make some interesting discoveries. . . .

Orange

This object is made up of a series of modular containers shaped very much like the segments of an orange and arranged in a circle around a vertical axis. Each container or section has its straight side flush with the axis and its curved side turned outwards. In this way the sum of their curved sides forms a globe, a rough sphere.

All these sections are packed together in a container that is quite distinctive both as to its material and its colour. Its outside surface is fairly hard, but it has a soft internal lining that serves as padding between the outer surface and the sections packed inside. The material is in origin all of

the same type, but it is suitably differentiated according to its function.

Each section or container consists of an envelope of plastic-like material large enough to contain the juice but easy to handle during the dismemberment of the global form. The sections are attached to one another by a very weak, though adequate, adhesive. The outer or packing container, following the growing tendency of today, is not returnable and may be thrown away.

The form of each section exactly follows the disposition of the teeth in the human mouth, so that once a section has been successfully extracted from the outer container it may be placed between the teeth, and a light pressure is enough to burst the envelope and extract the juice. Apart from juice the sections generally contain a small seed from the same plant that produced the fruit. This is a small free gift offered by the firm to the client in case the latter wishes to start a production of these objects on his own account. We draw your attention to the fact that while no economic loss is incurred in this gift, it gives rise to an important psychological bond between producer and consumer: few if any of the consumers will actually start growing orange trees, and yet this entirely altruistic concession (the idea of being able to do it if he wishes) frees the consumer from his castration complex and establishes a relationship of reciprocal trust.

The orange is therefore an almost perfect object in which one may observe an absolute coherence of form, function and consumption. Even the colour is exactly right. It would be quite wrong if such an object were blue.

The only concession to decorativeness, if we may say so, is the highly sophisticated material of the outer container, treated as it is in such a way as to produce the 'orange skin'

effect. Perhaps this is done to remind the consumer of the juicy pulp to be found inside the plastic containers. Anyway, a minimum of decoration must be allowed for, especially when as justified as it is in this case.

Peas

These are food products of varying diameters packed in bivalve cases of great elegance of form, colour and material. These cases are semitransparent and notably easy to open.

The products themselves, the case they come in and the adhesive used in packing all derive from the same source of production. This is not therefore a question of different operations with different materials and a process of assembly in the final stage of production, but of a precisely planned work programme, a genuine triumph of teamwork.

The object is monochrome but with noticeable variations of shade. These give it a faintly sophisticated appearance which does however have an appeal also for those consumers who are at the furthest remove from modern culture. The colour is, in point of fact, green, and moreover a green of the well-known type popularly known as 'pea green'. The choice of this colour was a sound one: introduced when production was first started, it has held its own against all rivals until the present day. It had considerable influence on taste, especially in the fashion and furnishing worlds, during the decade 1920–30.

The form of the pills contained in the bivalve case is fairly regular, though trouble has been taken to vary their diameters. The real originality of the product, the essential simplicity of concept, resides in the case. It is made up of two equal and symmetrical components (as is usual nowa-

days, for economy of production). These components are sufficiently concave to contain the pills, the shape, number and disposition of which is stamped into the case and clearly visible. The two components are joined with perfect accuracy (a point of great importance, since they are often exposed to rain), and held together by an adhesive which performs a double function: on the longer or outer side of the case it is simply an adhesive, while on the shorter side it acts as a spring-hinge. Holding the case like a knife between crooked forefinger and thumb, it is enough to apply the slightest pressure and the case will spring open, revealing all the pills arranged in a line according to size.

One characteristic of this product is the variation in the number of pills (or 'peas') in each series. This raises a problem that has often been the subject of discussion at designers' conferences all over the world. In general, greater variety helps sales as long as the characteristics of the product remain unaltered. In the case of pea production we come across a downright excess of variation. Available on the market are containers with dozens of pills, or with ten, eight, seven . . . right down to two, and in some cases one only. This excess implies, in effect, a certain waste. Who buys one single pea, or actually demands from his dealer a container with only one pea in it? Nevertheless, for thousands of years this object has been offered to consumers in this format, and consumers have raised virtually no objections. However, the likelihood is that this excessive variation stems from an initial error of market research. Such an error was certainly made before it was decided to proceed with production on such a large scale, and has since been perpetuated due to bureaucratic negligence.

Rose

Any rational concept of the function of Industrial Design must begin by rejecting the all too common production of objects that are absolutely useless to man.

These are objects that have come into being for no good reason, useful only on the most banal level: that of decor-

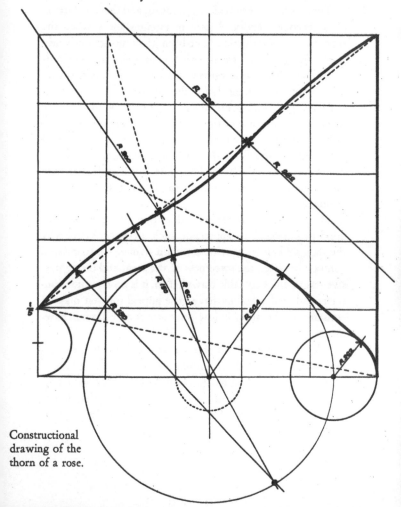

Constructional
drawing of the
thorn of a rose.

ation. They are entirely gratuitous and unjustified, even though in some cases they have a certain formal coherence. It is, however, a generally accepted fact that formal coherence is not in itself enough to justify objects produced without any previous analysis of marketing possibilities.

One such object is the rose.

This object is very widely produced, and this production often becomes really chaotic in circumstances when the economics of production have been given no serious study at all. The object is formally coherent and pleasantly coloured. It comes in a wide variety of colours, all of them warm. The distribution channels for the sap are well worked out and arranged with great precision; indeed, with excessive precision in the case of those parts which are hidden from view. The petals are elegantly curved, reminding one of a Pininfarina sports car design. The calyx is more reminiscent of the 1935 Venini line. The serrated leaves with visible nervation are tastefully though not symmetrically arranged.

How can a consumer who does not yet know his own mind be expected to appreciate such an object? And why the thorns? Is it to provide a certain *frisson*? Or to create a contrast between the sweetness of the scent and the aggressiveness of the vegetable claws? If so, it is a very crude contrast, and will certainly have little appeal for that mass of consumers who shop in low-price stores and bargain basements.

We therefore have an object that is absolutely useless to man, an object good for nothing better than being looked at, or at the most sniffed (though it seems that some producers have now invaded the market with roses that do not even have the virtue of scent). This is an object without

justification, and one moreover that may lead the worker to think futile thoughts. It is, in the last analysis, even immoral.

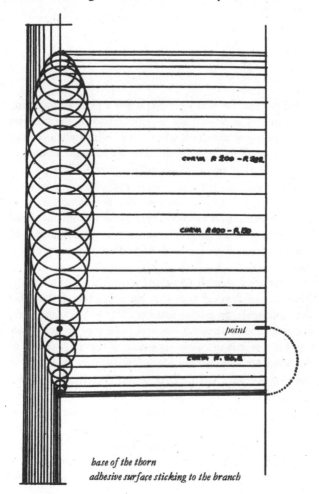

base of the thorn
adhesive surface sticking to the branch

A Piece of Travelling Sculpture

What is a car, for many people, if not a piece of travelling sculpture? It is something to ride in down the smartest streets in town, to exhibit whenever possible (when you can park, that is) in front of the most fashionable restaurant or at a vantage point in the main square. It is a piece of sculpture you can get into, rather uncomfortably in some cases, equipped with a sonorous and potent motor. Your aim is to transport it as smoothly as possible from one public exhibition to another. It is something to show your friends, that gives you the exact sort of prestige that people most value today.

There are a number of genres in this branch of sculpture. There is the classical type that has never been fashionable and will never go out of fashion. This is black and silver and more than somewhat funereal, but it is heavy with prestige because it is the most expensive. Pieces of sculpture of this kind are shown only for a few seconds at a time, in front of the principal theatres of the West End. They are propelled not by the owner himself but by a man of rather inferior class, dressed in a special uniform so that there is no danger of his being confused with the owner. The latter emerges slowly from his piece of sculpture and takes three dignified steps before disappearing into a blaze of lights. Then there are pieces of 'aggressive' sculpture, with shapes

that mimic the muscles of Mr Universe: low, flat shapes like coiled springs, all sharp edges and nervous curves. Red, as a rule. Their well-endowed bodywork is perhaps thrust rather further forward than nature intended, but actually this is just an optical illusion created by some infernal genius of a 'stylistic expert' specialized in making figurines of car bodies.

These are the two extremes: the V.I.P. car and the sports car. Evidently they correspond to social needs, or they would not be made and bought, and as long as our society is prepared to carry the millstone of certain prejudices round its neck we will always see them on the road.

Between these two extremes there is the more or less anonymous sea of cars that follow the current fashions while trying to look just that little bit different. And here we do occasionally find a designer who tries to make a decent, logical and functional car body. For example, he is so foolish as to think it would be a good idea if the bumpers on all cars were at a standard height from the ground. To try to get the air circulating properly he takes the trouble to consult an expert in such matters. He designs seats that will be well aerated and really comfortable. He considers the possibility of putting a small spy-hole low down at the back of the car so that the driver does not have to park completely blind. He attempts to solve the problem of dazzling lights, and finally he uses only those colours which show up well in fog or half-light. But he labours in vain. There remains the question of taste, of aesthetics and other subjective criteria which conspire to push a design, however well it starts out, right off the rails.

Either we ought to apply aesthetic criteria to everything, or forget them completely. Why do we criticize the 'line' of

a mudguard but never think of questioning the tread of a tyre? Did you ever hear of anyone refusing to buy a tyre because its design didn't go with his waistcoat? No, because a car is part machine and part drawing-room. Have you heard how these styling experts talk? Just listen to them: 'giving the interior a more intimate character . . . an inspired model . . . a delicious harmony of colours . . . a new, more slender line . . . an utterly personal interpretation . . . a real jewel', etc. Isn't this the kind of talk you expect to hear in a couturier's *salon*? And of course the word *salon* is actually used for exhibitions of new cars. And what do you think these gentlemen ought to be talking about? They should be discussing the real problems, aside from matters of aesthetics and personal taste and the art of sculpturing forms. Their designs should be based on statistics and lab tests, on the ceaseless study of form, function and cost.

Do you want proof that present-day designs are not what they should be? Well, you too will have seen shops crammed with thousands of different accessories for cars. Amongst a mass of useless gadgets you will also see a seat-back made of straw or cane for fixing to the seat of your car. It is to make your seat more comfortable and better ventilated. The implication is that your present seat is not comfortable. There are also gadgets of greater or lesser complexity for conditioning the air inside the car, an admission that the makers have not solved this problem. There are extra attachments to put on your bumpers because your present bumpers are either too high or too low. Or too feeble. And so one could go on.

However, the line of your car is smooth and elegant, and the colour is most *distingué*.

Luxuriously Appointed
Gentlemen's Apartments

'A laugh is an external sign of inner balance, while a gloomy face is the sign of gloom in the spirit.' (*Zen*)

You scarcely pass a new block of flats that does not display a sign reading: FOR SALE (or TO LET), LUXURIOUSLY APPOINTED GENTLEMEN'S APARTMENTS, or some such phrase. It is not the comfort of a home, or its snugness, or how convenient it is to live in, that interests the public. It is the luxury of it. This is particularly true of Italians, who have a mania for luxury.

What does luxury consist of, for the vast majority of the people who buy or rent homes? As a general rule, value is confused with price, and the things that cost most are the most luxurious. Someone accustomed to using an enamelled chamber-pot thinks that luxury means having a gold one. He will not change his habits, but he must have the most expensive thing of its kind: a gold chamber-pot. An example of this way of thinking is the famous golden telephone which was given to the Pope. This is shaped like a perfectly normal everyday telephone, but it is made of gold, engraved gold, gold embossed with the Papal arms, gold embellished with the symbols of the Evangelists, with the keys of St Peter and the monogram of Christ. Gold.

And what is our Luxuriously Appointed home like? Well, at any rate in Italy, the first essential is marble marble every-

where, even where it is no use, or where it needs an enormous effort to keep it polished (for marble must be polished, and very highly polished too, so that it reflects the crystal chandelier with crystal clarity). It must be marble even in the entrance hall, where all the dirt is brought directly from the street. In such a case, however, the marble is covered with a strip of red carpet which of course (being by the front door) gets dirty at once and is in turn covered with a strip of white material which shows the dirt terribly and has to be covered with plastic. So we enter the house and tread at once on the plastic, but warm in the knowledge that under it there is white material and under that the red carpet and under that the marble. And we know, of course, that the marble is very highly polished.

Then there are cut glass chandeliers, even in the porter's little cubby-hole. It is a luxurious cubby-hole, lined with marble, and the smell of cabbage and fried foods; for it is not clean air and the ventilation system that matter, but luxury. The walls of the apartments themselves are painted in impossible colours or covered with very expensive papers, while in the drawing-rooms with their astronomically expensive carpets and red velvet armchairs the conversation is often interrupted by a Niagara of noise from the lavatory (for sound-proofing has been neglected in favour of more luxurious wallpaper). The windows, needless to say, are very large indeed, very large and panoramic. The panorama one enjoys from them consists of a series of other panoramic windows in the Luxuriously Appointed Apartments opposite. Through these windows, designed to bring the traffic right into the heart of your home, the sun also enters violently, ricochets off the brilliant marble and strikes the retina with great force. However, it must be said that by

using washable cream-coloured net curtains and thick non-washable velvet curtains the effects of all this light can be very much reduced.

But it is not marbles, chandeliers, panoramic windows and outrageously expensive things which make a gentleman's residence. If the person living in it is a gentleman the house will match him: it will be modest, quiet, hospitable, and will have all the necessary comforts without falling over backwards to achieve them. We have all seen old farmhouses which have been done up, furnished in simple good taste, restored with due respect for the original architectural style and with the comforts one really needs. But what we see far more often are Luxuriously Appointed Freaks lived in any old how, decorated in the Arabic-Bergamasque style, filled with fake baroque furniture (as if there had been no other styles in history), with badly proportioned rooms and colours that clash with each other and stun the visitor. These are uncultured houses, built by uncultured builders for uncultured tenants.

When a lot of money comes along before culture arrives, we get the phenomenon of the gold telephone. And when I say culture I don't mean academic knowledge, I mean information: information about what is happening in the world, about the things that make life interesting.

Knives, Forks and Spoons

I think it would be useful for young married people who are setting up house together to know what they have to get in the way of knives, forks and spoons. I mean, of course, a complete service, so as not to cut a sorry figure when the duchess comes to dinner.

An inquiry which I have carried out in the knife, fork and spoon industry reveals that today there is an implement for every specific purpose, that each operation and each single item of diet requires its own implement (such as the traditional special equipment for fish), and that it is absolutely wrong to serve one dish with the implements designed for another. For example there are several different kinds of knife for steak, with normal edges or razor edges, with toothed or saw edges of various types. Then there is one with a wavy edge that is sharp on the inside of the curves but not on the crests of the waves where it touches the plate. Thus the plate remains unharmed, and the knife stays sharp.

There are special implements for eating fondue and others for lobster. There is a small knife for peeling oranges, with a saw edge and one large protruding tooth: the large tooth is used for cutting through the rind without piercing

the segments, the saw-edged part for removing the neat quarters of peel.

There is a tiny knife for spreading bread and butter and there is another for use at the bar, with a tooth for lifting bottle-tops, a saw edge for peeling fruit, and three teeth at the end for pronging the slice of lemon and putting it in the glass.

There's quite another knife for cutting the slices of lemon to put in tea, for as everyone knows it is not the actual juice of the lemon that flavours tea, but the liquid contained in the countless little pores of the rind. Well, this knife is specially made so as to break open these pores and extract the maximum flavour.

There's a knife for chips, with a zigzag blade, another for shredding orange or lemon peel (or carrots or potatoes), there's a kind of scalpel for fruit, there's a curved knife for grapefruit and a matching spoon in the shape of a grapefruit section. There's that tubular object with an opening on one side, for coring apples. There's a spoon-shaped knife for making miniature 'new' potatoes out of big old hoary ones. And is there anyone who doesn't know about the knife for making slits in chestnuts? Could any really smart household be without one? What would happen if the duchess, on a sudden impulse, ordered a roast chestnut for dinner?

Then there's the broad, rounded saw-edged knife for tomatoes, made in such a way that the slices remain on the broad blade, and thus you can arrange them on the dish without touching them with your fingers – the very fingers with which you have just been holding the whole tomato.

And no kitchen must lack a battery of small knives for assorted uses, uses for which no really specialized instrument has yet been perfected. Certainly no Italian kitchen must be

without a knife for cutting fresh *pasta* into *tagliatelle* or *maltagliati*, or be deprived of that little wheel with a zigzag edge and a handle, that you roll across a sheet of *pasta* to give it a zigzag edge like the border of a sample of cloth. In the same way, every English kitchen must be equipped with various knives for trimming pastry and making pretty patterns on it, as well as moulds and things for pressing out shapes, and an object (*not* an eggcup, if you please) for holding up the middle of piecrusts. You will also need a saw-edged bread-knife, a curved knife for making rolls of butter, a slice for creamy cake (made of silver) and a wicked short dagger or skean-dhu for opening mussels. Then there is the stubby round-bladed knife for cutting hard cheeses such as Parmesan. Just the thought of it makes your mouth water.

I must also tell you about the knife for cleaning and peeling mushrooms, the potato peeler with an adjustable blade, a knife for asparagus and a pair of tongs for eating them with. For snails you must also have a pair of tongs and a fork with miniature prongs. And what about all the other kinds of cheese?

Well, there's the general purpose cheese knife with a blade broad enough to serve helpings on. There's a shorter and broader knife with the handle set nearly an inch higher than the blade, specially for soft cheeses, and one with an adjustable double blade for slicing gruyère. Some softer cheeses need a palette knife, of course, while mozzarella demands a broad semicircular blade and gorgonzola one of only moderate width. Nor must you forget that short, broad rounded knife for spreading butter on extra-thin slices of bread. For cutting such slices in the first place you need a small saw-edged affair that will not make the soft bread crumble. For semi-hard cheeses I recommend a medium-sized

knife with the end bent up at right angles and three teeth
on the tip. It can be used for offering cheese to guests, as
well as for cutting it up. For rather less semi-hard cheeses
there's a similar knife but with barbed ends to the teeth
so that the cheese doesn't slip off in transit.

Housewives in Northern Italy will often serve *polenta*,
which is maize-flour cooked into a sort of slab porridge.
They of course will need a wooden spoon, if possible with
a handle in the shape of a corn-cob. The effect of this is ge-
nuinely rustic, and when they bring such spoons to the table
their city guests will almost explode with astonishment, as
if to say, 'What a daring hostess!' But do not worry, gentle
housewives, for the wood and the shape of the corn-cob are
quite appropriate to *polenta*, and sooner or later your guests
will realize this and smile with delight at your rustic spoon
(coupled with the fact that the *polenta* itself was first-rate).

This list of indispensable tableware is naturally incom-
plete. I have left out the whole range of spoons, from serving
spoons to ice-cream spoons, from those with bent handles,
made for children, to those especially for strawberries. I
have left out the ladles and the strainers, the tin-openers and
the corkscrews, the fork that is also a spoon and the fork with
the cutting edge. I have quite forgotten to mention the spring-
operated tongs for serving spaghetti, sugar-tongs, ice-tongs,
nutcrackers for walnuts, hazelnuts, almonds . . . I have ne-
glected the special fork for capers and the other for olives,
the tubular spoon for marrow-bone, the palette knife for
omelettes, the shears for cutting up chickens. Nor have
I included the pincers for frogs' legs, or the perforated spoon
for fried marrow-flowers.

If this partial and incomplete list leaves you wondering
how you are going to pay for everything, or how you can

possibly build a piece of furniture large enough to contain all this stuff; if you are in two minds about the style to choose, or the material (for it goes without saying that all these things can be obtained with handles made of silver, steel, ceramic, horn, hoof, perspex, etc., and in modern style, more modern style, ultra-contemporary style, antique style, more antique style, antediluvian style, comic or serious, garish or restrained, elaborate or rustic, to suit all tastes), then you can always fall back on something else. What I am suggesting is most original, and I am bound to agree is a last resort. The table implements used by the Japanese do not give you any feeling of inferiority, and they do not have to be washed because at the end of the meal you simply throw them away. So you need not worry about where to keep them, or about moth and rust corrupting, or that thieves will break through and steal your silver. They cost very little and millions of people have been using them for thousands of years. They are made of natural wood, like two giant toothpicks ten inches long, and in Japan you can buy them in packets of a hundred in any big store. They are easy to use, and the food is cut up beforehand into mouthful-sized pieces.

Millions of people have been using them for thousands of years. But not us! No! *Far* too simple.

And That's Not All . . .

For years and years architects and designers all over the world have been designing thousands of chairs, upright chairs and armchairs, all different and all the fruit of infinite inventiveness. I have even designed two or three myself. But it seems that the problem has not yet been altogether solved, because architects and designers all over the world are still going on designing chairs, just as if all their efforts up till now had been wrong.

A very thorough market research campaign on people's taste in chairs has established that they must answer the following requirements: they must be comfortable, luxurious, rustic, fanciful, strictly technical and functional, broad, narrow, high, low, hard, soft, flexible, elegant, rigid, compact, large and impressive, cheap, good value, obviously expensive and socially impressive, made of one single material, made of a variety of materials; while the favoured materials are rare and rough, as well as refined and crude.

So there we are. Chairs must be made for indoors and out, for the drawing-room, the office, the waiting-room at the doctor's or at the railway station, for playing cards in, for taking tea in the garden, for lunch, for the seaside, for holidays in the mountains (a vast range), very low with a very

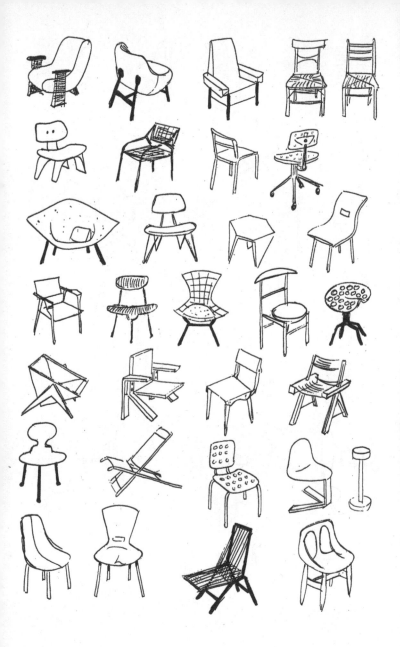

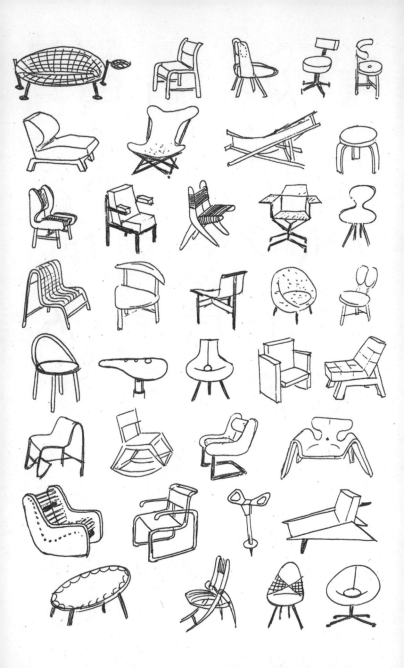

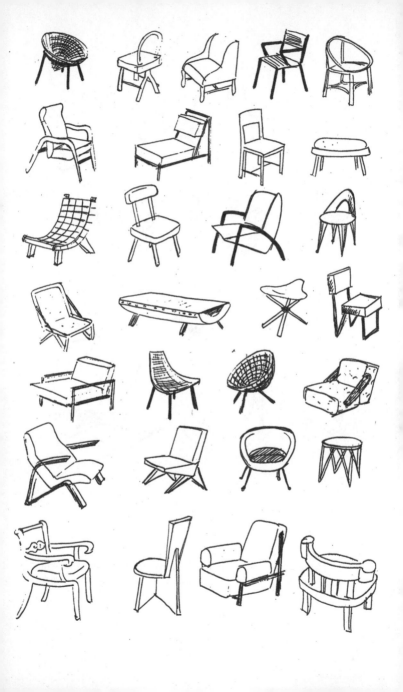

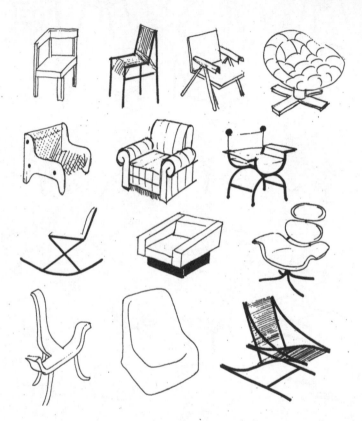

'Today we are moving towards forms that, once achieved, will remain unchanged and unchangeable for all time.' (*Pier Luigi Nervi*)

high back, very high with no back at all (for the bar), for boutiques, for buses, for churches, for camping.

There is Grandma's chair and there is Aunt Mary's, there is Father Bear, Mother Bear and Baby Bear's chair; there are temporary perches at airports and permanent thrones in the clubs in St James's.

They can be made of carved wood, curved wood, pressed wood, plasticized wood; they can be dovetailed, screwed, glued or pegged; they can be sandpapered, stained, painted, varnished, matt, semi-glossy or perfectly dazzling. And all this goes for all kinds of wood from poplar to ebony.

Or they can be made of iron or steel, welded, bent, burnished, enamelled, chromium-plated, nickel-plated, pressed, rubberized, magnetized, plated with brass or copper. They can be extruded, tubular, in square section or in oblong, in U-section, T-section, E-section, XYZ-section.

Or they can be made of aluminium, anodized, coloured, natural, sandblasted, pressed, in polished sheets or perforated sheets, coated, plasticized, tinted, cast. Then we have brass, cast iron, bentwood, malacca, wickerwork, stag's horn, elephant's tusks . . .

With all these materials a good designer can make a chair that may be dismantled, a folding chair, a swivel chair, a fixed chair, a chair on castors, a chair that becomes a bed, a chair that one can raise or lower, a chair with a reclining back, a rocking chair, a chair for anyone anywhere at any time. In Relax, Delux, Rex, Tex, Mux; in velvet, velveteen, cotton, canvas, travertine; in nylon, orlon, maulon, moron.

My phone rings. It is the editor of a Contemporary Furnishing Review. He wants a design for a new chair, for publication in the next issue. . .

Fancy Goods

'You're always so full of ideas. Give me an idea for a Christmas present, not one of the ordinary things you find in the usual shops.'

How was I to set about it? Well, first of all I had to get an idea of what my lady friend meant by ordinary things. I did a tour of the gift shops that sell fancy goods, just to see what they had in stock.

In one shop I see a brass boot, size 25 (approx.). 'I'll have a pair of those,' I say. 'We have only one, sir.' 'What can I do with one boot?' 'It is not a boot to wear on the foot, sir. It is a boot to keep umbrellas in,' the assistant explains, smiling patiently as one would at a madman. I am greatly embarrassed by this gaffe, and leave the shop at once, nearly tripping over a marble cat decorated with floral reliefs and serving as a doorstop. I am beginning to learn.

As I stand indecisively outside the shop my glance happens to light on a copper frying-pan hanging on the wall. It is not meant to be used as a frying-pan, of course, because it has clock-hands attached and numbers from one to twelve. Ah ... then it is a clock. It is in the shape of a frying-pan because it is for the kitchen. And a clock for the lavatory?

It is a cool evening and the bright shop-windows spill gold

into the street. Here we have a pair of brushes shaped like cats and held together at the sides by magnets. An ashtray in the shape of a woman's hand, and one of those old-fashioned irons that you put embers in: but this one is made of china, is embellished with forget-me-nots, and is full of chocolates. And here is a board for cutting salami and ham on, shaped like a pig. A corkscrew like a pig's tail with a brass pig for a handle. A potty for a child, in the shape of a duckling (it seems that children love to take it out on ducklings). A lamp like a bunch of flowers, a lamp like a bunch of grapes. A pipe like a shoe, like a bull's head, like a revolver, like a corn-cob, like a A moneybox in the shape of an apple, a pear, a shoe. A bottle like a cottage, a cottage like a bottle. An ashtray in the form of a little house with a chimney: when you poke your cigarette in at the front door, smoke comes out of the chimney.

A photo-frame like a pocket watch, scissors like a flamingo, a salt-cellar like a wheelbarrow with a spoon like a shovel. A dish for fish shaped like a fish, a dish for pig's foot shaped like a pig's foot, a tureen for tomato soup shaped like soup. A hammer like a fish, a fish like a hammer, a cheese-dish in the form of a sitting hen, a thermos flask for ice, shaped like a football.

A dish for fruit in the shape of a leaf, an old wooden cradle for use as a magazine rack . . .

These are certainly not objects produced by designers, for designers do not have such raging imaginations. They confine themselves to making candlesticks that look like candlesticks. But look, what have we here? An antique gun hung on the wall as a hatstand, with a row of hooks soldered along the barrel. Or an enormous key with smaller hooks, for hanging real keys on. A cigarette lighter in the shape of a revolver, a revolver in the shape of a cigarette lighter. An umbrella like

a pagoda, a table-lamp made of a clarinet (likewise, a trumpet), with a lampshade of sheet-music: take your choice, *The Barber of Seville* or *The Magic Flute*. A pair of pretty slippers like rabbits, a beer mug like a boot. A miniature Tyrolese hat, in bronze as a paperweight. A priest's hat as a cigarette box, a bishop's hat as a cigar box, a paper-knife in the shape of a sword, a barometer in the shape of a rudder, a clock also disguised as a rudder, a blotting pad like a steam-roller, a wrought iron cigarette box in the shape of a vintage car, a bar for dispensing drinks from in the sitting-room, in the shape of a safe. An iron suit of armour that is really a fridge, an ashtray in the shape of a rapier, its point planted in the ground. A book-bottle, a statue-bottle, a corn-cob bottle, a bottle-candlestick, a ship in a bottle, even some wine in a bottle (some wine in a book, some wine in a statue, some wine in a corn-cob), a bottle of liqueur with a sprig of rue inside it. A huge clothes-peg made of mahogany and brass, for use as a paperclip. A stone made of foam rubber for use as a paperweight for airmail paper. An enormous walnut-shell as a bowl for walnuts. An enormous shell as a bowl for shellfish, an enormous spoon for bringing coffee-spoons to the table in, a miniature funeral urn, in marble, for use as an ashtray.

By this time my head is spinning and I don't know for sure whether what I am seeing is really there. I don't know whether to put my cigarette ash into someone's hand or to screw the light-bulb into the soup-tureen. What on earth can I say to my lady friend? If we have gone this far at Christmas, where will we be at carnival time?

However, I do say something. I say, let's buy a pipe that is really a pipe, let's fill it with real tobacco, light a match that looks like a match and works like a match, and apply it to the pipe-pipe. Let us have a cup of coffee in a cuplike cup on a

table-table near our chairlike chair, and read a good book-book. And my friend gets all upset. She climbs into her Mini tarted up to look like a Cadillac and roars off into the mist, sounding like a Ferrari.

RESEARCH DESIGN

Iris

In springtime when the Irises (*Iris Germanica* to the experts, flagflower to the profane) begin to show themselves, still wrapped up in a kind of tissue paper, before they open their violet petals with a kind of yellow scroll in the middle, that is the time to pick a flower and take it home.

Take a razor-blade and cut it clean across the middle (see illustration), and you will see how all its parts are arranged before the flower opens. Nothing is untidy, each part is in its proper place, and each is already coloured.

This is a way of getting to understand nature, observing natural forms in the process of transformation, following their cycles of evolution. From its birth until the moment when it bears its fruit a plant gives us a series of explanations as to why its forms are as they are and arranged in just that way.

It is very interesting to study the nerve-systems of leaves, the arrangement of the main and the subsidiary channels, and to distinguish the two networks. Also to follow the development of pine-cones from the time they appear until they finally open. It is fascinating to watch the growth of any plant, and to observe its changing forms.

'Copying nature' is one thing and understanding nature is another. Copying nature can be simply a form of manual dexterity that does not help us to understand, for it shows us things just as we are accustomed to seeing them. But studying the structures of nature, observing the evolution of forms, can give everyone a better understanding of the world we live in.

Growth and Explosion

The secrets of any trade that is pursued with serious intentions are more than a series of rules and working methods based on logic and experience and applied so as to obtain the greatest possible effect with the least amount of effort. They also include a continuous process of observations, thoughts and ideas that are pushed ahead even if at the beginning they seem to have no logical basis.

Driving one day down one of the big motorways I happened to see a big bush in the middle of a meadow, and this set a whole train of ideas going in my mind. Whether or not they might have some practical application must be left to the future to decide. In any case, here they are. That big bush in the meadow looked to me like an explosion caught and fixed at its point of maximum expansion. If I were to take a photo of that bush, slightly out of focus, and show it to you side by side with a photo of a hand-grenade exploding, the two things would have the same form. One might say that a firework is nothing other than a tree or a big artificial flower that grows, blooms and dies in the course of a few seconds. After that it withers and falls to the ground in unrecognizable shreds. Well then, let us take this firework and make it last a month, stretching the time element but leaving

Diagram of the growth of a conventionalized tree (drawn from memory after a study by Leonardo). Each arc represents a year, and each year the branches fork (in theory an infinite number of times). In fact, they do so according to natural relationships and surrounding conditions.

Diagram of an atomic chain-reaction. Considered in the abstract, as a diagram, it is similar to the growth of the conventionalized tree. The only difference is the time element: instants instead of years. If we could slow down the explosion so that a thousandth of a second equalled one year, perhaps we might be able to catch sight of strange atomic flowers with fluorescent colours . . .

'Concern yourself with things before they come into existence.' (*Tao Te-ching*)

everything else as it is. What we will get will be a flower, with all the visual characteristics of other flowers. Or let us imagine that the seed of a tree might explode like a bomb. In such a case we would have a tree in a matter of minutes, rather as we can watch the growth of a flower on film by running the film through quicker. Our tree would have straight branches, as in an explosion the bits fly off in straight lines before describing a parabola. In the normal way the explosion of a tree happens very slowly and the branches, instead of being straight, grow crooked for a number of reasons: atmospheric conditions, the course of the sap, the prevailing wind and many others. But of course there are small fireworks that describe trajectories not unlike the tortuous growth of a vine or olive.

A drawing of Leonardo's (which I here reproduce from memory) shows the growth of a conventionalized tree. It starts from the trunk and then produces a series of forks. At the same time the thickness of the branches lessens, until the whole thing takes on a rounded form quite similar to that of a nuclear explosion, the so-called 'mushroom'.

The process of growth shows the same progression as a nuclear chain-reaction: $2-4-8-16-32-64$, etc.

At this point my ideas come to a halt, because they arose in the first place purely from visual observation. But it may happen that a simple observation stimulates deeper research. Or on the other hand it may simply demonstrate a coincidence between one visual image and another.

But today we are in the habit of breaking down all known things into their component parts. We know the effects of the absence of gravity, a thing that was inconceivable not so long ago; a man floating in space, alone, without wings or mechanism of any kind! This we have all seen. Time is a

component which it is hard to imagine any different from how it has always seemed to us. But in the last few years things have been happening even in this field of human experience.

Concave-Convex Forms

These plastic forms are made out of a square of metal netting with a mesh of about four or five millimetres. The square itself can be of any size, and depends on the width of the netting you buy. When you have cut the square, you need to

turn the wires on the cut side back on themselves, so as to pre-
vent the last wire (parallel with the cut) from shredding loose.
This needs patience and a pair of pincers: one wire upwards,
the next down, and so on.

Then you decide on a number of points on the square sur-
face. These may be determined either by measurement and
proportion or freely, by trial and error and following the
dictates of the form as it emerges. In the first case the object
will be mathematical, in the second it will be a free form.
When you have marked these points with a knot of string,
begin bending one of the corners of the net towards one of the
points. The net is flexible and not difficult to work with.
Fold the net slowly back on itself, keeping it smooth and
round with the hand, until the corner touches the point you
are aiming for. Tie it there with a piece of fine wire. Then go
to work on the other corners, and a plastic form will emerge
from a piece of netting that was perfectly flat before. This
form will be semi-transparent and will have the same plastic
characteristics as a shell, or as certain topological or mathe-
matical forms.

I began making these forms in 1948, and exhibited them
as objects to be hung from the ceilings of restaurants and so
on. The slightest movement of the air makes them turn, and
if you project light on to them they throw a constantly chang-
ing shadow on to the walls and ceiling, or even into a corner.
The shadow projected looks like a drawing, with an effect not
unlike that of an old print, but when it is in motion it gives
beautiful *moiré* effects that appear and dissolve like a cloud.

These objects were a by-product of my 'useless machines',
and they too are fragile and therefore not easily saleable com-
pared with things cast in bronze and destined to sit in mus-
eums, perfectly still, for centuries.

Continuous Structures

In 1961 I had the first show of my 'continuous structures' at the Galleria Danese in Milan. There were about a dozen objects in the show, ranging in size from one foot high to something over six feet. They were made of bent sheets of natural anodized aluminium, and were composed of modulated elements joined together. The basic elements, joined to others like them, gave these structures their particular forms; and these elements were of different kinds. Each kind produced a different final form, and each object emerged as one of an infinitely modulated series.

Thus it is in the natural structures of matter: the nervation of a leaf, the geometrical elements of a mineral, a quartz crystal or cubic pyrites. In the same way these simple elements confer form upon objects that can be thought of as belonging to a kind of man-made nature, structured in the same way as the natural things we know. They could be produced in an infinite series, just as theoretically a mineral could take on an infinite number of forms while at the same time remaining recognizably itself, classifiable according to its particular kind.

The elements of the continuous structures are based on the elementary formulae of the square and the right angle. The

simplest of these elements consists of two squares soldered together along one side, and each having a straight cut made from the centre to the middle of another side, parallel to the joint. Two of these elements can be fitted together to form the cell of a certain kind of structure. This is the basic form. Other elements slotted into one another to form a chain, until the last slots into the first, make up a continuous structure that may be composed of any number of equal parts. In addition, the object may be put together in a number of ways, according to whether the pieces are mounted all facing in one

direction, or turned in the opposite direction, or alternated, or otherwise varied. The final result has something of the look of a piece of abstract sculpture, or of something between sculpture and the mineral world. And just as in nature the forms of minerals or plants or anything that grows according to a particular internal structure are limited by surrounding conditions, so the limits of a continuous structure depend on what the owner wants and the surroundings he intends to put it in.

Natural forms are continually modified during growth by their surroundings. Theoretically all the leaves of a single tree should be identical, but this could only happen if they were able to grow in surroundings completely devoid of outside influences and variations. All oranges should have an identical round shape. But in reality one grows in the shade, another in the sun, another in a narrow space between two branches, and they all turn out to be different. This diversity is a sign of life as it is actually lived. The internal structures adapt themselves and give birth to many diverse forms, all of the same family but different.

There are no works of art that show us this aspect of nature. In the usual way a piece of sculpture shows us one aspect of reality and one only. These continuous structures, with their capacity for variation according to the likings and moods of the spectator, bring to mind a whole realm of nature as yet unexplored by the plastic arts.

Naturally, this puts an end to the already tarnished image of the work of art as a rare and even unique thing, independent of what it expresses. Each continuous structure is reproduced in a certain number of 'dissimilar' copies, dissimilar in the number of elements used and in their arrangement. Two continuous structures made of the same number of

elements can be different, according to the temperaments of whoever assembled them.

In the Japanese magazine *Graphic Design* (No. 3, p. 40) there is a picture of one of these structures. Assembled by Shuzo Takigouchi, it is completely different from the one owned by Michel Seuphor of Paris, though it is made of the same number of identical basic elements.

Another thing about these structures is that unlike conventional pieces of sculpture they do not have a base, a top and a bottom, a back and a front. They can be placed any way up, or hung on a wire or a wall. Any similarity to abstract sculpture is purely accidental, in that certain abstract sculptures could perhaps catch one aspect of one phase of a continuous structure. The structures do not have a 'composition', an interplay of masses and spaces fixed once and for all. The

only fixed and invariable thing is the basic element, but even this becomes variable according to how many are used and how they are arranged in the object as a whole.

This too is a requirement of art today. We need to give the spectator more room to penetrate into the work itself, and works which allow this are called 'open'. It is a form of art that adapts itself to the artistic sense of the beholder. In times past people wanted the artist to explain in very clear terms exactly how he saw the world in every detail. The beholder was content to react to the personality of the artist, who in everyone's eyes became a genius, the greatest, the one whom nobody could imitate. Today the person who looks at a work of art is more sensitive, more accustomed to simultaneous and intense stimuli, to brand new technical and scientific concepts, so he is no longer so interested in a 'closed' work of art. Art that is too defined, conclusive, and limited to one aspect of a thing, leaves a man of today standing isolated and apart: either he accepts the *fait accompli* or he gets nothing from it. There is very little actual participation involved. Everything that does not coincide with the particular vision of the artist has to be excluded. But in an open work of art a person participates much more, to the extent of being able to change the work of art according to his state of mind.

The Tetracone

The tetracone is an object produced on a small scale for the purposes of programmed art. It consists of a cube with sides eight inches long, within which four cones revolve slowly at different speeds. The cube is open on two (opposite) sides, so that the cones inside it may be seen from front and back. They are arranged so as to fill the entire areas of the spaces thus presented to the view. From the front one sees one combination of colours, from the back the same combination but with the opposite colours.

Each cone contains a small motor and is fixed to the inside of one of the walls of the cube. The cones are cast in aluminium with an internal cavity that contains the motor. All the wires pass through grooves cut into the inside of the box, which is then covered with black plastic. On the base there is nothing but a plug for electric current and a switch.

The dimensions of the box are the basis of all the other forms. Each element is related to every other one and to the whole, not according to the old rules of the Golden Section, which do not apply in this case, but by simple geometrical relationships. The diagonals of the sides of the box determine the size of the cones. The diameter of the base of each cone is equal to the internal length of the sides of the box,

while its height from base to apex is equal to half that amount. The surface of each cone, if projected on to a flat surface, is equal to three quarters of the circle which has a radius of half the diagonal of the side of the box. Each cone is painted in two complementary colours, half one colour and half the other. In this case the colours are red and green. Complementary colours produce an optical vibration at the dividing line between them, and this gets rid of the material. I had better explain this: if you look at complementary colours in the right lighting conditions you will lose all awareness of the material they are painted on. You will therefore be looking purely at the colour and not at the material.

The programming part of the operation consists in deciding the speeds at which the four cones will turn, and the combination of the number of seconds that each cone takes to make a complete turn. In this way one can establish not only the three spatial dimensions but also an effective (as opposed to poetical or metaphysical) dimension of time, which in the tetracone I am describing here is 1,080 seconds. This means that theoretically the combinations of colour repeat themselves every eighteen minutes.

The tetracone therefore offers the viewer a changing combination of two complementary colours. Looking at the object, with its shifting chromatic effect, is supposed to lead the viewer to meditate on the mutability of nature (which in traditional art is presented as static). Because of the slowness with which the change occurs, the colour combinations are at first perceived one by one, like the single frames in a film, but if one watches for longer the effect becomes that of a continuous transformation, from all green to all red, in the course of eighteen minutes.

The art of the past (painting and sculpture) has accustomed

setting a position for cones in a cubic space

base of cone = side of the square

the flat surface of each cone takes up ¾ of a circle

the surface of each cone is divided in two equal parts of complementary colours

kinetic distribution of the speeds

time, in seconds, for each full turn

kinetic direction of four motors built into the cones

'As long as we try to slow up and limit spontaneous change by means of a static symbol we will never be able to understand or to act in a really effective way.' (*Alexander Dormer*)

'The greatest freedom comes from the greatest strictness.' (*Paul Valéry*)

us to seeing nature as static: a sunset, a face, an apple, all static. People go to nature looking for images such as these static things, whereas an apple is in fact a moment in the process from apple-seed to tree, blossom, fruit. In nature nothing is still. The idea of nature fixed at 1 June 1969 or a face fixed at thirty-two years and eight days old is completely unreal; quite apart from the fact that if we stop nature we shall never be able to understand her.

When we fly over the Pole we see a sunset that lasts for hours, and then slowly changes into dawn. Sunset and dawn are the same thing; day and night are both continuous in the world. They never stop. What kind of art can tell us about these facts of nature? What have we learnt from the art of the past about the cyclic movements of nature? Or about the transformations of forms and colours? Think of a tree when it is a seed, and then imagine it tall and green and flowering, laden with fruit. Think of it in autumn, and in winter. All this is nature and nature is all of this, not just one moment of it.

The programmed art of today aims to show forms while they are in the process of becoming, and for this reason it cannot use forms such as painting and sculpture use. On the contrary, its means must be dynamic, and it must be prepared to make full use of motors and other industrial materials.

What really counts is the information which a work of art can convey, and to get down to this we have to abandon all our preconceived notions and make a new object that will get its message across by using the tools of our own time.

'The principle of a form is not *it is* but *one does*.' (*Bauhaus*)

Yang-Yin

This Yang-Yin symbol is of Chinese origin, and is more than three thousand years old. It represents the unity created by a balance between two opposing forces that are equal and contrary.

This unity is visibly represented by a disc made up of two equal parts, one black and one white. These parts seem to be in constant movement in a clockwise direction.

The two opposing forces are interpreted as natural forces, and from their balance comes life itself. Yang is the positive, active, masculine force, and subsists in dryness, heat, hardness, the sky, light, the sun, fire. It is firmness and brightness. Yin is the negative feminine principle present in everything passive, such as cold, damp, softness, mystery. It is in all mysterious, secret, evanescent, cloudy things, and in everything inactive. The shadow on the north side of a hill, the estuary of a river, earth and water: these are Yin.

Millions of people, amazed by the glories of nature and stunned by the terrible havoc of natural calamities, recognize this definite and mobile symbol as the symbol of life itself.

We ourselves get tired, and rest in order to recover our equilibrium. If our eyes are struck by a sudden bright red light, we see a complementary green colour until our retina has returned to normal.

This rule about complementary colours, or the balance of opposites in general, must always be borne in mind in some kinds of work.

In his book *The Hidden Persuaders*, Vance Packard describes an experiment made by psychologists to determine the best colour for a detergent packet. Three trial packets were made up, one yellow, one blue, the third yellow and blue. Housewives chose the yellow and blue packet (complementary colours in equilibrium), saying that in their opinion the yellow packet contained a corrosive detergent, and the blue packet a detergent that was too mild. The yellow and blue packet contained a detergent that was just right. It goes without saying that the detergent in all three packets was one and the same product.

Moiré

Printers use various kinds of screens. Some have round dots, others square, and the distance between the dots also varies. Take two screens with square dots which do not quite touch (not as on a chessboard, where the squares touch at the corners), printed in black on a sheet of transparent paper. Place one sheet on top of the other so that the patterns are superimposed and then shift the top sheet very slightly round. This will produce images that were not there before, symmetrical patterns like flowers, or like Arab decorative motifs.

The images change according to the angle at which the sheets are placed to one another. Not only does one image change into another, but it is interesting to watch the actual process of transformation taking place.

My friend Marcello Piccardo and I once made a short film of this. We called it *Moiré*.

The equipment for filming and projection was set up on the basis of objective calculations, starting from basic elements and then developing according to the nature of the theme. The music was contrived by Pietro Grossi in his sound-research laboratory in Florence; it has the same structure as the images themselves. The film only lasts three minutes, because by then we had run through all possible variations of image.

Techne — art
Asobi — art, but also game (in ancient Japanese)

Direct Projections

Direct projections of what? Well, of a dragonfly's wing for example. Take the ordinary frame that you use for colour slides, get two squares of thin glass of the right size and sandwich the dragonfly's wing between them. Needless to say, you should take a wing from a dead dragonfly and not kill one specially to make an amusing experiment. You then project the wing with the ordinary projector that you use for photographs of your summer holidays, enlarged to six feet high for the greater delight of your guests. And *voilà*, you see everything. You see its design and how it is made. Then when you get bored with that (and I know just how quickly you do get bored) get a feather, just one of the tiny feathers from your grandmother's softest cushion. And there is the feather six feet long, absolutely beautiful, with its hundreds of filaments that you now notice for the first time are themselves long feathers.

If you can't find your grandmother's feather cushion, take a foam rubber one and cut a slice off it as thin as a Communion wafer (sorry Vicar). You will see the structure of the foam rubber, and it really is like a drawing of foam.

But seriously, how can we make full use of a slide-projector in this day and age?

We can use it as a means of expression, just like any other artistic technique. Just as one can buy tubes of paint for painting pictures, so one can obtain sheets of coloured Cellophane and other substances that can be used for projecting. They are very thin sheets and come in a wide range of colours, so that you have no lack of choice, from the lightest colours to the darkest. You can put two or three thicknesses of one colour to darken it, or you can superimpose different colours to get any mixture you like.

You can also find sheets of transparent coloured plastic, as thick as a visiting card. These can be scratched, engraved, burnt or dipped in solvents to obtain many different effects.

Apart from these there are materials which have a particular structure and therefore (when projected) a particular design, such as the nervation of leaves, some nylons and other artificial fabrics, mica, threads as fine as hairs, crystalline powders, and so on.

All these things should be used with the utmost freedom. It is no good trying to make a portrait of Aunt Mary or a view of Loch Lomond. At least, one *could* do it, but it would be a lot of trouble to get a rather poor result. The best thing is to use small pieces of these materials and put them together as the mood takes you, without any pretence at creating a masterpiece, working by trial and error. Simply by trying things out you will become involved in an absorbing game (the ancient Japanese word for art was *asobi*, which also means game). You will find that this game gives the chance of self expression, that certain colours and forms which come into being by chance provoke certain sensations, and that certain strange colours remind you of something. You will find out that these images evoke feelings and memories from the distant past: the colours of a terrace where one played

'To understand means to be capable of doing.' (*Goethe*)

as a child, the waters of a river full of rapids and whirlpools, a square in the shadow of a great looming castle (I mention things at random). Then you can ask the other viewers to talk about their reactions. It will be an interesting experiment.

When the experiment is over you will still have a collection of little slides to keep in a cigar box (one of those wonderful cigar boxes that smell of wood and good tobacco).

'When man ceases to create he ceases to live.' (*Lewis Mumford*)

Hyposulphite crystals in a lantern slide. The slide is used just like a normal negative, put in the enlarger and printed on normal paper.

Projections with Polarized Light

'The colour receptors of the retina have been evolved and con-
ditioned in the course of ages by the combined colour stimuli of the
natural scene. Static coloration can never assure enduring psycho-
logical satisfaction; it is unnatural . . .
. . . Colours should set each other off refreshingly, not only
in space, side by side, but also in time, one stimulation follow-
ing another. Any unchanging combination becomes unbearable
for an extended period, even if the initial selection of colours
seemed perfect. Colour perception, like form perception, takes
place in the space—time continuum. To treat it in relation to
space alone is in itself a defective approach.' (*Richard Neutra*,
Survival through Design)

This kind of projection was the result of experiments I
made in 1954, in the hope of obtaining effects with changing
colours. My first ninety compositions for direct projection
are now in the Museum of Modern Art, New York, where I
gave a personal showing of them.

These are made on the same principle but using a
polarizing filter, while the slides are filled with plastic
materials of various kinds, but all absolutely transparent
and colourless.

The idea of using projection for works of art is not new.
Many people will remember the magic lantern projections

of realist images, made on sheets that were slid through the projector. But what I was doing is different in that for the first time it uses polarized light as a means of generating and animating colour.

Polaroid has the same effect as a glass prism, which as everyone knows breaks down a ray of white light into all the colours of the spectrum (that is, all the visible colours). Polaroid is generally used in experiments to show the stresses in material when subjected to tension, or in crystallography for the examination of certain crystals and materials to discover their structure. It had never been used in art before.

If we take two sheets of polaroid and sandwich a piece of Cellophane between them, folded over two or three times, we shall produce a colour. By revolving one of the two polaroids we can observe the whole arc of the spectrum except the complementary colours.

We learn from the folded piece of Cellophane that it is the thickness of the colourless material that determines what colour we see: one thickness gives no colour, two thicknesses produce red (and its complementary green), three produce blue (and its complementary orange), etc. The chromatic effect naturally depends on the nature and structure of the material used. Over a period of years I made a lot of experiments to find out what materials were best for obtaining various effects. I discovered, for example, that polythene can be stretched and ironed out, like a piece of elastic that does not return to its original shape. But thanks to the difference in thickness caused by ironing, it produces particularly soft colours. I found other substances, such as mica, that give beautiful colours, and also certain types of Cellophane and some crystalline substances and ultra-fine slices of certain minerals (that however are difficult to use).

These experiments gave me a whole mass of possibilities so that now I can compose a whole changing and living world of colours and images, and all within the tiny scope of a lantern-slide.

Each material may be treated in different ways to give different effects. With one of these colourless compositions I can produce about fifty variations, simply by rotating the polaroid during the projection. It is as if a collector were able to show off fifty different works by the same artist.

In the Home of the Future people will be able to keep a small box containing hundreds of 'pictures' for projection.

The Square

As broad and as high a man standing with outstretched arms, since the times of the earliest writings and in the earliest stone engravings the square has stood for the idea of the enclosure, the house, the village.

Enigmatic in its simplicity, in the monotony of its four equal sides and four equal angles, it generates a whole series of interesting figures: a group of harmonious rectangles, the Golden Section and the logarithmic spiral which is found in nature in the organic growth of many forms of life.

The logarithmic spiral is based on a series of 'golden' rectangles arranged in progression around the smallest of them.

A square cut as shown in the above diagram can be turned into an equilateral triangle simply by turning the pieces round as on hinges at the points marked.

Its many structural possibilities have enabled artists and architects of every age to give a well-produced framework to their buildings and works of art. It is present in every style produced by every people on earth at any time, both as structural element and as the base and background of particular decorative motifs.

It is static when resting on one of its sides, dynamic when balanced on one of its angles. It is magic if it contains numbers, and can even be diabolic if these numbers are related between themselves and to the square or the cube. It is found in nature in many minerals. It is a curve, according to Paeanus. By cutting it up and putting the pieces together in a different arrangement you can make it into triangles or

A square cut as shown by the white lines on the black figure at the top can be put together again in many different ways.

rectangles. In ancient times it had the power to keep the plague at bay. It has provided the proportions of famous ancient cities and of modern buildings: Babylon and Tel el-Amarnah were square, while of the buildings we may mention the Parthenon, the Cathedral at Pisa, the Palazzo Farnese in Rome, and Le Corbusier's 'square spiral' museum. In the designs of many churches the square spaces beneath the semicircular domes are the most logical spaces possible, just as the square shape of a photograph corresponds to the round lens with a minimum of waste or distortion.

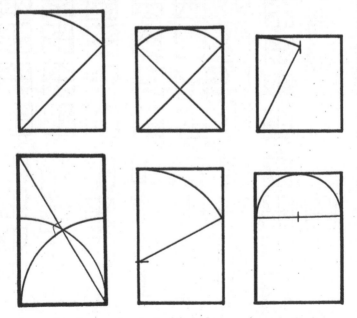

Proportioned rectangles obtained from the square by projecting its own dimensions outside itself.

On the Acropolis of Olympia the gymnasium, the *the-ecoleon*, the *leonidaeum* and other buildings had a square ground plan...

It has given birth to ancient games that are still played today: chess, draughts, halma, nine men's morris.... Then there are the square dances of the American frontier, the hollow squares of the British redcoats.

At the time of the eastern Chin it gave a stable square form to Chinese ideograms. It contributed to the structure of the letters of our alphabet, as well as to the Hebrew and other alphabets. A double square of matting is the basic module of the traditional Japanese house. Twenty-eight squares compose the surface of a brick. According to an ancient Chinese saying, infinity is a square without corners.

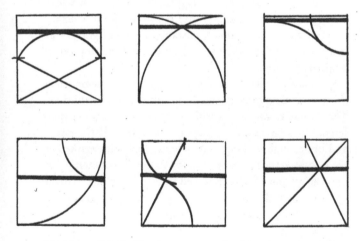

Divisions of the inside of a square starting from the main combinations obtained between lines and curves derived from the dimensions of the square itself.

The Circle

If the square is bound up with man and his works, with architecture, harmonious structures, writing and so on, the circle is related to the divine. The circle has always represented and still represents eternity, with no beginning and no end. An ancient text says that God is a circle whose centre is everywhere and whose circumference nowhere.

The circle is an essentially unstable, dynamic figure. From it arise all rotating things, and all vain efforts to produce perpetual motion.

Although it is the simplest of curves, mathematicians think of it as a polygon with an infinite number of sides. Then if one takes one invisible point away from the circumference of a circle it is no longer a circle, but a Patho-circle, and causes highly complex problems. Any point marked on the circumference of a circle destroys the idea of eternity by creating a point of departure and therefore also an end to the circumference. If this circle, marked with a point, rolls over a flat surface, the point describes a curve that is known as a cycloid.

It is easy enough to find circles in nature. We only have to throw a stone into calm water. The sphere, on the other hand, emerges spontaneously in soap bubbles. A section of

tree-trunk reveals the concentric rings which mark its growth.

A circle drawn by hand proved Giotto's mastery. A circle is always one of the first figures that children draw. When people want to gather closely round to watch something, they automatically form a circle. In this way came the form of the circus and the arena. Famous painters have used round surfaces to paint on, basing their composition strictly on the circular form. In certain cases, as in Botticelli's *Virgin with Child*, the effect of the work is spherical.

At the very beginnings of writing we find the circle in nearly all alphabets and systems of ideograms. Circles also occur often in the drawings of children below school age, in those of illiterate adults, and of prehistoric man.

A disc put down on a flat surface can never be crooked. That is why plates are almost always round: easier to lay a table with. If they were hexagonal, square, octagonal or rectangular, they would be hard to line up neatly for dinner. And more important, we can say of a sphere that it is absolutely impossible to knock over.

Nearly all the many failed experiments in perpetual motion used the wheel or circle. Both in genuine attempts to construct a machine that would turn for ever by itself, and in demonstrations that this is impossible, unknown inventors and learned men such as Leonardo da Vinci and Villard de Honnecourt have made static models. One of the oddest cases is that of the Marquis of Worcester, who amongst his other inventions made this wheel shown above. It was supposed to rotate on its own, thanks to the weight of the balls that rolled outwards along the tilted spokes and thus acquired more leverage than the balls near the axle.

The ingenious Marquis later became famous for his piquant sauce.

An Arrow Can Lose Its Feathers but Not Its Point

This is not a proverb, as you might think at first sight. It is simply an observation about a common directional signal that in recent years has lost almost everything, but kept its most essential part.

If there is an object known to everyone, even to savages, and one that can be used to indicate direction, that object is the arrow. The arrow leaves a taut bow and always flies in the direction of its point.

Whoever chose the arrow as a signal to indicate direction must evidently have thought of this. And of course, for this purpose, it doesn't matter if the arrow is made of ebony, teak or a willow wand, if the arrowhead is made of forged iron or tiger's bone, or whether the flight that keeps it on a straight course is made of feathers endowed with magic powers to guide it to its mark. What matters is the shape.

At the beginning of the nineteenth century, arrows used as signs had scarcely begun to be stylized. The part representing the feathered flight was simply filled in with black, with straight lines at top and bottom and curved lines at front and back to suggest the softness of the feathers. 'Otherwise,' some critic of the times is sure to have said, 'no one will understand what it is.' Later the arrow became more rigid, and the

'I TAO PI PU TAO': If the idea is there, the brush can spare itself the work. (Ancient rule of Chinese painting.)

point sharper, as we find on the roadsigns of *circa* 1910.

We will not go into all the byways of this development, but stick to the main road. The arrow loses its slender shaft, the breadth of the flight being continued down the whole length until it meets the head. Certainly it is more noticeable like this. One could even do away with the indented notch at the heel of the arrow. And indeed, it was done away with. By now it was realized that all one's attention should be concentrated on the point of the arrow, for that is the part that actually conveys the message. The rest could be eliminated. The shape arrived at is still seen on the traffic signals that tell you which way to turn: a white arrow on a blue background.

Early in the twentieth century, with Futurism and the first experiments in geometric design, the arrow grew thicker still. This time it was the width of the arrowhead that determined the thickness of the shaft. The arrow became a rectangle with a triangle cut out of the heel and stuck on the front instead. The cut-out at the back suggests that the designer was uncertain of getting his message across clearly with this sign, for the triangular cut-out represents the shape of the feathered flight, long since done away with. We still find this model of the arrow on our roads, where it is used to mark dangerous bends.

But soon the heel of the arrow was cut straight across, and the last suggestion of the flight vanished. And so it remains, an oblong with a point at one end.

Now we have become so highly trained, and our reflexes are so fast, that the arrow has even lost all trace of its shaft. After all, what matters is the point, and the point remains in the shape of the black triangle we often see at the bottom righthand corner of magazine pages, indicating that the article we are reading is continued on the following pages.

But the arrow has not yet finished its process of trans-formation. The most recent signs accompanying the names of towns along the Italian motorways have just the leading edge of the arrowhead, as in the last of my illustrations. Every now and then some artistically nostalgic draughtsman puts in an old-fashioned arrow, but is at once overwhelmed by an army of points, just the extreme essential tips of arrowheads that we take in in the blinking of an eye, almost without noticing them.

Theoretical Reconstructions
of Imaginary Objects

theoretical reconstruction

genuine parts

genuine parts

Every now and then archaeologists digging in the Sahara, or in some cave that was once on the sea shore, find a fragment of animal remains. By close examination they discover that it is a bit of the tooth of a creature that lived in the Upper Palaeolithic Age, some hitherto unknown species of Man.

This fragment passes into the hands of other experts, who try to reconstruct the whole animal, man or object (as the case may be) on the basis of structural measurements and analysis of the material and so on.

We see a lot of these reconstructions in Natural History museums, especially of course in the departments dealing with life on our planet in remote eras of which we know little or nothing. In other departments we see vases reconstructed from tiny scraps of pottery found in some tomb, and if there is a design on these an effort is made to reconstruct this as well as the pot itself.

As everyone well knows, the genuine part is left just as it

was found while the reconstructed parts are made of quite different materials, partly to make the reconstruction work stand out.

Let us carry this idea over into the field of art. Let us set our imaginations to the task of reconstructing something which we assume to be unknown and build up a fantastic and unexpected thing according to the structural and material data provided by the few fragments we have to go on.

Let us in fact make a theoretical reconstruction of an imaginary object, basing our work on fragments of unknown function and uncertain origin.

Whatever emerges from this, we will not know exactly what it is, or what world it belongs to. Maybe it will belong solely to the world of aesthetics and imagination. This is how we do it.

We take a few scraps of black paper, or coloured paper, or paper from a packet, wrapping paper, a sheet of music, a rag, or anything else that comes to hand. We tear the first of these into two or three pieces and drop the pieces on to a sheet of drawing paper. Then we go on to the next kind of paper. The objects (they are nothing less than the fragments we have discovered) will fall on to the paper any old how. We then look at them for quite some time, and maybe we will want to move something, but we must not do this according to any rule of logic, but simply (as Hans Arp said) according to 'the rule of the moment'. We must 'feel' something that makes our hand move. Having made any required changes of this kind we go on to join up the various fragments. To do this we must study the outlines of the fragments and their internal structures. If a fragment is torn it has a different outline from one that is cut, so that torn fragments will be joined by ragged lines and cut fragments by straight ones.

Sheet music is marked with the lines of the stave and the notes, and we assume that these will behave rather like the threads of a torn piece of cloth, only they will be rigid. If a fragment is stained or marked in any way, the stains will be reproduced also in the reconstructed part.

And thus, slowly and without thinking of Raphael, we shall have reconstructed something that never existed, something no one has ever seen, something that even we had no inkling of, something we will at once bung into the waste-paper basket because it is a mess.

If at first you don't succeed. . . .

Exercises in Topology,
or Rubber-Sheet Geometry

'The atomic age in which we live is beginning to change our ideas about reality. The darkness of the unknown world is being illuminated. Visions at one time incompatible with the concept of reality are now no longer imaginary. From here there will arise new forms of visual art.

Science creates new means of knowledge. But the new inquiry is simply a return to the curiosity of children inquiring into the unknown. In this sense art and science are twins. Art serves as mediator between the imagination of the child and the adult's sense of reality. The fate of visual art in the atomic age will depend on the way in which these tendencies of mind unite.' (*Felix Deutsch*)

Geometrical figures and solids are bodiless, abstract and perfect. In geometry a cube of lead and a cube of sponge are both of them just cubes, and if their sides are of equal length the two cubes are equal, whatever they are made of.

But topology gives these forms material being, and wants to know what would happen to a tetrahedron if all its sides were sheets of rubber joined together. Topology opens the form up, shoves its hands inside, pulls it about as a furrier does the skin of an animal. Topology breaks form down on to a plane surface and finds that a tetrahedron reduced to two dimensions is a triangle. In geometry a circle is the place of residence of all the points that are equidistant from a given point. A circle with some points nearer the centre than others is no longer a circle.

In topology a circle might be made up of the links in a chain, rather than just a series of points. One can push it about as much as one wants to, as long as it retains the essential fea-

ture of dividing space into two parts, one inside the figure and one outside. It can have any shape you like, even a square. In topology this has the same value as the circle.

The prince of geometrical instruments is the pair of compasses. The tops in topology is the pair of scissors. Topology cuts things up, puts them together again in a different way and says they are still the same, or that their qualities are equal, or that they are completely absurd like the famous Möbius Strip. Is it possible that a plastic body has only one surface? That it has no inside or out? That it is confined by a single line?

Let's see. Take a paper strip two inches wide and eight or ten inches long (the exact measurements don't matter). Place the two ends together so that the edges touch. You will have a ring, or (looked at another way) a cylinder two inches high. Open the ring again and twist one end round 180 degrees. Now place the two ends together as before, and what do you see? That what was the inside of the cylinder is now, for half the circumference, the outside, and that the two lines which previously formed the top and bottom of the cylinder are now one single and continuous line. Now does that seem right to you? But it's not all. . . .

Things were complicated still further by a certain Mr Klein, who produced a kind of bottle with a neck that turned back into the bottle through one of the sides and then came out at the bottom, joining up with the outside of the bottle. But in point of fact this bottle *has* no inside or outside. It is all one continuous surface.

These exercises and many others arose from a brain-twister posed to a bunch of good-for-nothings idling their time away in a café in Königsberg during the first half of the eighteenth century.

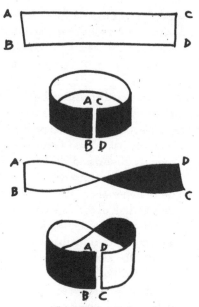

The Möbius Strip.

Now it happened that the River Pregel flowed through that ancient university city, and that in the middle of the river there were two islands. Joining the islands to each other and to the river banks were seven bridges. It was raining. One of the idlers said: 'One afternoon in March a tramp wanted to take a walk across all seven bridges without crossing any of them twice. How could he do it?'

There was an embarrassed silence. They ordered another round of beer, and several hours later they all went off about their business without having spoken a single word. But the problem had been squarely put, and slowly it made its way

around the world. It was Leonard Euler of Petersburg who came forward with a solution, discovering that the thing was possible only if the vertices were even. Casting the islands and their bridges into the form of a graph, Euler was able to demonstrate his theory.

In 1847 the German mathematician Listing published the first treatise on topology, and today any geometry book worth looking at has some topological problems at the end.

Topology obviously has a great future, for a few happy insights, as apparently absurd and idle as the ones about the tramp and the bridges or the rubber tetrahedron, can give rise to a great number of important problems that in turn help us to a deeper understanding of the things around us and their transformations. Why don't we pose a few more problems? We are only prevented by the idea that it is not a serious matter. It is not serious, for example, to consider the thermic aspect of geometry. Why not? If we can meditate on the transformations of a rubber cube or a paper strip, why can we not also wonder about the changes caused by heat or anything else? What happens to a cube at 20°Centigrade? At 50°? At 100°? What does it become?

EXPERIMENTS

1. A geometrical form exposed to intense heat loses a dimension

Take a cube of lead each side of which measures one twenty-fifth of an inch and place it in the centre of a vast horizontal iron sheet. Heat the iron gradually to x degrees and then let

it cool. Watch how the cube is altered by the heat. The corners gradually become round, first the lower and then the upper ones. The base expands, its corners getting increasingly rounder. They will never become square again. The cube then looks like a squat rounded pyramid, and finally a large flat disc.

Is there a relationship between the radius of the circle thus formed and the original side of the cube? Between the area of the circle and that of one side of the cube?

The experiment is irreversible. If we heat up the leaden disc again we do not produce a cube.

2. *Transformation of a triangle into a sphere*

Take some Plasticine and roll it out flat as housewives roll out pastry. Cut out an equilateral triangle with each side about eight inches long. Fold the three angles in towards the centre of the triangle until they touch. You have a hexagon. Make three more folds, following the diagonals, and you have a triangle again. Repeat this operation for as long as the material permits. When folding is no longer possible hold the object in the palm of one hand and, exercising a light pressure, move the other hand in a rotary manner upon it until the object has become a sphere.

This experiment clearly shows that the sphere weighs the same as the triangle. What we have to do is establish the relation between the sides of the triangle and the maximum circumference of the sphere, between the apothem of the triangle and the radius of the sphere, and between the area of the triangle and that of the sphere.

It seems most likely that $x = 3a + (6E + \cdot 2) \div r2 + aT + bT + cT - 1$, or $X = 3t - 1$.

3. The fourth dimension of a cylinder

Take a cylindrical receptacle and fill it with H_2O. What you will have is a cylinder of water. Raise the temperature of this cylinder to $100°$ Centigrade, and you will observe the progressive reduction of one of the dimensions and one only: the height lessens, while the other dimensions remain the same. At the moment when the height of the cylinder of water has been reduced to zero you will have the complete transformation of a three-dimensional solid into a dynamic fluid mass with four dimensions. This experiment holds good for any solid form obtainable from a liquid. The form resulting from such an operation is incapable of recuperation and cannot be measured, like all forms that have a fourth dimension.

4. Transformation by abrasion

Take a series of geometrical solids made of the same material and ranging from the tetrahedron to the icosahedron. Put them in one of those rotating cylinders that are in fact specially made for rounding off objects with unwanted protuberances. It will be interesting to see how long it takes to rub off all the corners and reduce all the objects to spheres; to see the time-relation of the sphere derived from the tetrahedron to that derived from the icosahedron; to discover the relationship between the material and the form; to find out who on earth would make such calculations and how much he would ask for the job.

Two Fountains, Nine Spheres

Designs for fountains based on the principle of the water-meter: a double-triangular container, as shown in the photo, is held in balance on a supporting structure. A trickle of water falls from a hole in the tube above, filling one half of the container. When the weight of the water overcomes the weight of the empty half, the container tips over and pours the water out. Meanwhile the other half slowly fills up until. . . .

Photo and plan of the first fountain designed in 1954 and erected in front of the Book Pavilion at the Venice Biennale Exhibition.

A series of slightly tilted water-shoots started from a height of rather over six feet above the ground and eventually discharged into a black hole. During its long journey from

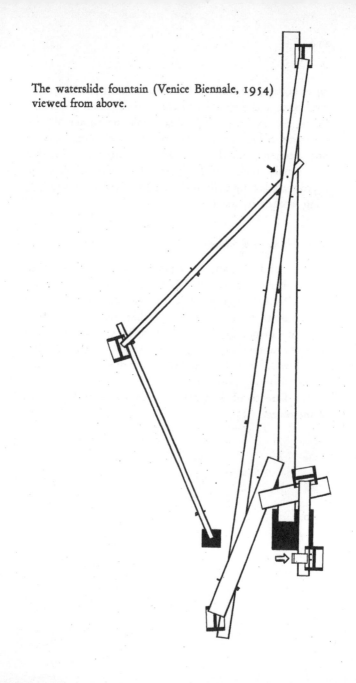

The waterslide fountain (Venice Biennale, 1954) viewed from above.

top to bottom the water was carried across a lawn, over some shrubbery, and every time it changed direction it splashed almost silently on to and spread over the surface of glass sheets rather like lecterns. The tilted runnels were made of zinc sheeting painted yellow and supported by tubes that were simply stuck into the ground. One of these tubes conveyed the water up to the highest point. Otherwise the whole thing worked by itself.

Nine spheres in a column

Drawing and diagram of the programmed art object called 'Nine spheres in a column' (shown at the Mostra Olivetti, 1962). Nine transparent plastic spheres are held in a vertical column by three vertical sheets of glass. Inside each sphere is a white diaphragm. The bottom sphere rests on the turntable of a motor that gyrates very slowly. All the spheres thus turn slowly, by friction, and the white diaphragms are constantly changing position.

The diameter of the spheres determines all the dimensions of the object.

sphere

glass

*base as high
as a sphere*

base with motor

APPENDIX

The Machines of my Childhood (1924)

The Place of the Machine was far away.

We would set off in the early hours of the afternoon, leaving town by way of the Abbey of Vangadizza and keeping along the bank of the Adigetto river, shaded by an avenue of scented limes. After miles of dusty, sun-parched road we would come in sight of the huge dyke. It was bigger than our whole town and dominated everything, blocking out the horizon as far as you could see to right and to left.

Some stone steps led up to the top of the dyke, but we clambered breathlessly up the great bank of earth through the sparse lucerne that was cool on our bare knees.

The view from the top of the dyke left us breathless, not least because we had rushed up the slope so fast. And there was our Machine, floating on the water near the bank. It was an old wooden watermill that might have been built by Robinson Crusoe himself.

The sky was immense and the wind ruffled our hair; the great mass of the grey waters of the Adige flowed slowly by, here and there forming a dangerous whirlpool. For me and my friends that water came from the unknown and disappeared into the unknown once more, carrying with it bits of

trees and dry branches, tufts of grass and uprooted bushes, and sometimes weird objects and dead cats.

One at a time we would cross the wooden gangway between the mill and the river bank, and there we were on the raft. It was made of dozens of spars all joined together and resting on two large floats. In the middle of the raft was the cabin, with a thatched roof. Beside the cabin, on the side towards the river, the Great Wheel turned slowly. The whole Machine was made of old wood, now quite grey, the hard grain standing out and the softer parts carved out by the weather. Only the metal axles of the Wheel and the millstones were polished to brightness by continual wear; they were inside the cabin in half-darkness, among the flour-sprinkled spiders' webs and full sacks with almost human forms. The Machine squeaked and creaked, groaned and grumbled, and one could follow its rhythms in time with the turning of the Wheel. And the Great Wheel itself provided an ever-varied spectacle: with slow deliberation it drew from the river marvellous green weeds and water-plants like soft glass, held them up flashing in the sunlight, raised them as high as it could and then slowly lowered them, immersing them again in a shower of spray that fell with the sound of gentle rain. This sound formed a continuous background for all the other noises of the mill. Every now and then one would catch the smell of flour or weeds, water or earth, rotten wood and moss. And sometimes the Great Wheel would fish up a chicken-feather along with the plants, or a piece of paper or a leaf to vary its brilliant compositions.

And while my friends poked about in all the corners they could reach, tried to pick the lock of the cabin door or threw stones at the waterbirds, I stayed near the Great Wheel, with the river flowing ceaselessly under the spars where I sat as if

suspended in air, watching the endless display of colours and lights and the movements of the Great Wheel.

This very day I went by car to see if the mill was still there. The road is a short one, the dyke a small one, the mill has gone.

Penguin Modern Classics

WAYS OF SEEING
JOHN BERGER

How do we see the world around us? This is one of a number of pivotal works by creative thinkers whose writings on art, design and the media have changed our perceptions forever.

John Berger's *Ways of Seeing* changed the way people think about painting and art criticism. This watershed work shows, through word and image, how what we see is always influenced by a whole host of assumptions concerning the nature of beauty, truth, civilization, form, taste, class and gender. Exploring the layers of meaning within oil paintings, photographs and graphic art, Berger argues that when we see, we are not just looking – we are reading the language of images.

'A slap in the face of the art establishment ... *Ways of Seeing* revolutionized the way that Fine Art is read and understood' *Guardian*

'There is nothing distanced about Berger. He handles thoughts the way an artist handles paint' Jeanette Winterson